How to Draw Magical Mythological Creatures

CREATE UNICORNS, DRAGONS, GRYPHONS, AND OTHER FANTASY ANIMALS FROM LEGEND

J. C. Amberlyn

MONACELLI STUDIO

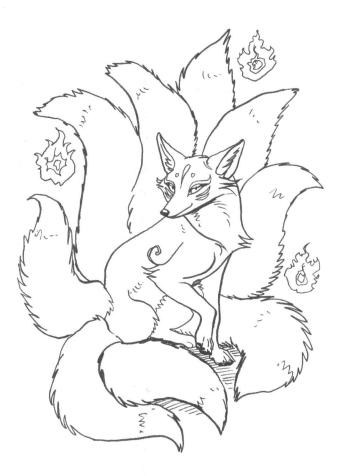

Library of Congress Cataloging-in-Publication Data

Names: Amberlyn, J. C., author.
Title: How to draw magical mythological creatures : create unicorns, dragons, gryphons, and other fantasy animals from legend / J. C. Amberlyn.
Description: First edition. | New York, New York : Monacelli Studio, [2019]
Identifiers: LCCN 2018048495 | ISBN 9781580935241 (trade pbk.)
Subjects: LCSH: Animals, Mythical, in art. | Fantasy in art. | Drawing—Technique.
Classification: LCC NC825.M9 A43 2019 | DDC 743.6—dc23
LC record available at https://lccn.loc.gov/2018048495

ISBN 978-1-58093-524-1
Printed in China

Published in the United States by MONACELLI STUDIO, an imprint of THE MONACELLI PRESS

Design by PATRICIA FABRICANT
Cover Design by PATRICIA FABRICANT
Cover Illustrations by J. C. Amberlyn

10 9 8 7 6 5 4 3 2 1

First Edition
MONACELLI STUDIO
THE MONACELLI PRESS
6 West 18th Street
New York, New York 10011

To my mom and my family for their love and support through the years. To my uncles, Stan and David, for showing me the power of storytelling and myth. To Rusty, Dan, Jocelyn, and Jessica, for their friendship. To Lynne for those wonderful kirin figurines and other fun things. Last but not least, to Scarlett, who is just starting her journey of discovery. I hope she'll have many grand tales to tell of joy and adventure.

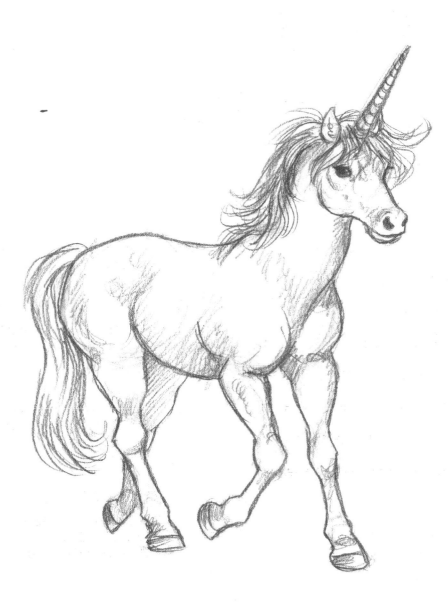

Contents

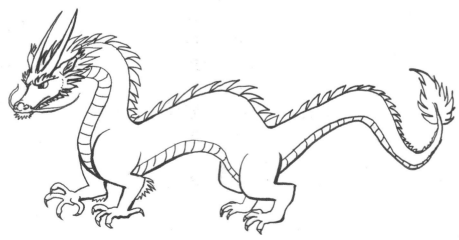

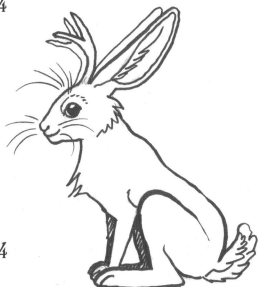

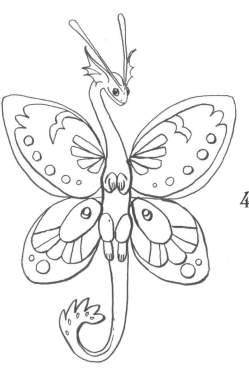

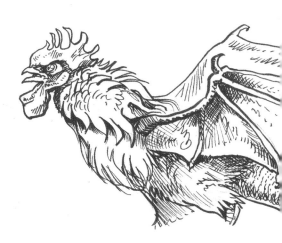

Introduction

Mythology is a language of stories and imagery that helps define a culture. Every culture has its own mythology, a collection of tales that almost everyone knows. It provides people with a common narrative and visual framework that can inform them about their society's language, moral systems, religion, and social life. One of the interesting things about this mythology is how there are common elements in these stories shared across cultures; a common human experience we can all relate to. Animals are part of this culture and the human imagination has given rise to many fantastical creatures, often based on real animals but with an extra, often magical, twist. Many things lurk in our subconscious, a common thread among humanity that vast groups of people can relate to and understand. These archetypes, or recurring motifs in art and stories, occur repeatedly in sometimes (seemingly) vastly different cultures. The legend of a bird that can regenerate itself by fire, or is associated with fire somehow, is repeated with the Phoenix as well as several other mythological birds ranging from the Russian firebird to the Chinese fenghuang. Many mythological birds have a special antagonism towards serpents, much like how hawks and eagles will attack snakes. Lions, or lion-dogs, tend to be symbols of power and guardianship across the world. One of the wondrous things about learning mythology is learning about not only our differences across cultures but our similarities. Understanding mythological creatures is a part of understanding ourselves, and the world around us.

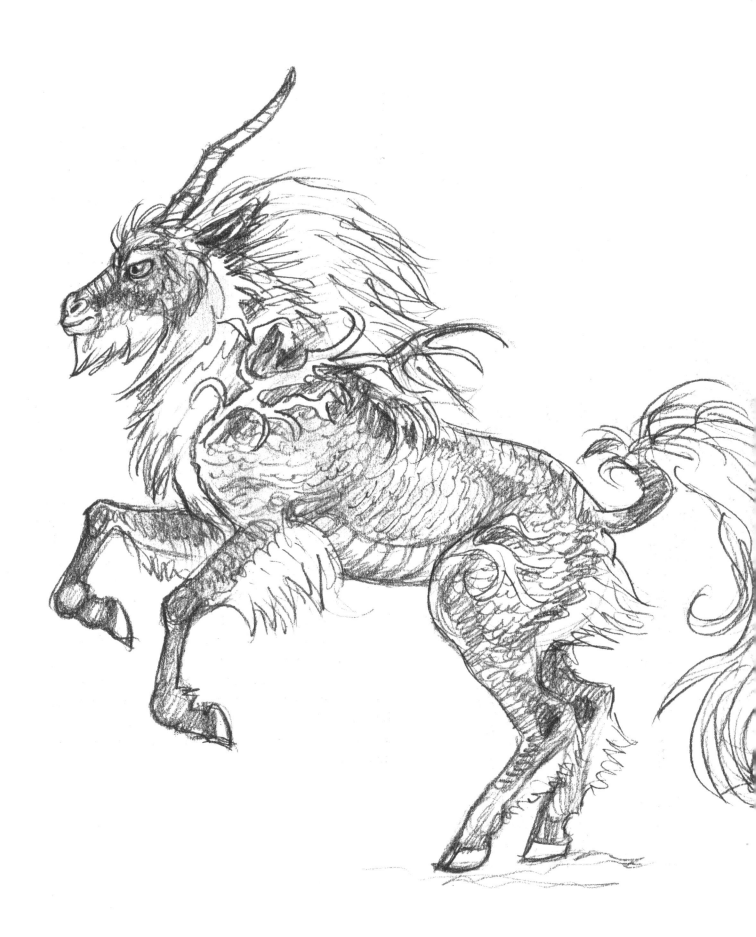

9

About This Book

This book will take a look at some of the mythological creatures that share a place in the world around us through our legends, art, history, and hearts. Including all the mythological creatures around the world is beyond its scope, but I have aimed to include many commonly known creatures and tried to get a sample of some of the lesser-known ones. Here I focus primarily on animals and animal-like creatures rather than the more humanoid ones like mermaids, centaurs, or goblins (which would almost require their own book). I've tried to include a range of step-by-step drawing demonstrations, from the very simple to more advanced instructions. Having a step-by-step drawing demonstration for each creature was not feasible here, but I've attempted to include as many as possible. Each creature feature does include at least one illustration and an explanation of the creature's basic habits or history. I hope this book will fire up your own imagination and get you drawing creatures of your own, as well as fuel the desire to explore the rich and diverse cultures of the world, all with their own wisdom to share.

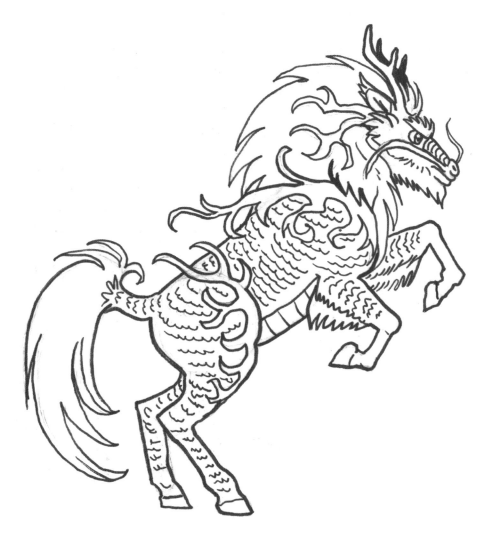

Art Materials

There are many ways to approach art nowadays, from a simple pencil, eraser, and paper to drawing on the computer. When using traditional media (paper and pens, color markers, paint, etc.) look for acid-free paper and pens with acid-free ink. This will ensure that your drawings last longer and don't yellow with age. If you use color markers, the more expensive professional markers will provide you with better results (but will cost more). I personally use a lot of Tombow ABT Acid-Free markers and Copic markers. I often sketch with a mechanical pencil and then finalize a drawing with an acid-free ink pen before erasing the pencil lines once the ink has dried. I used a Pentel 0.5 mechanical pencil and a Tombow Calligraphy pen for many of the drawings in this book. I enjoy using a kneaded eraser, which allows me to shape the eraser into a point if I want to only erase a small part of a drawing. Having a good scanner allows you to scan your images in and continue working on them on the computer or save and publish them online.

When it comes to digital art (on the computer), there are many programs to choose from as well as many ways to draw. I find using an artist's tablet with a tablet pen is helpful and much easier to draw and color with than trying to use a computer mouse. There are a variety of artists' tablets on the market. Look at reviews and price range to buy the best-quality one you can afford. There are many programs, including standards like Adobe Photoshop, Clip Studio Paint, or Autodesk Sketchbook Pro, as well as free programs you can find online. When creating art, try to make images as high resolution as possible without slowing your computer down. Making images 300 dpi (dots per inch) or 600 dpi is a good start. (Many web images are 72 dpi and look good online but are not good enough quality to print at a large size.) Computers with fast processing speeds and high-quality graphic cards help, too.

1

Basics of Anatomy and Overview of Drawing Mythological Creatures

In this chapter we'll look at all the basics for drawing two- and four-legged creatures—including anatomy, weight, shape, and features—and how to combine creatures to create your own originals.

Four-Legged Animals

When drawing a fantasy creature of any sort, it is helpful to keep real-life anatomy in mind. If the animal looks plausible, that goes a long way towards making it believable. How do you make a creature look plausible? By paying attention to its inner bone and muscle structure and trying to create something that looks as if it could move, eat, and do other day-to-day actions. Even cartoony creatures will benefit from some basic structure that looks believable. Many mythological creatures are based on real animals, and knowing those real animals, inside and out, can help your mythological ones look more convincing.

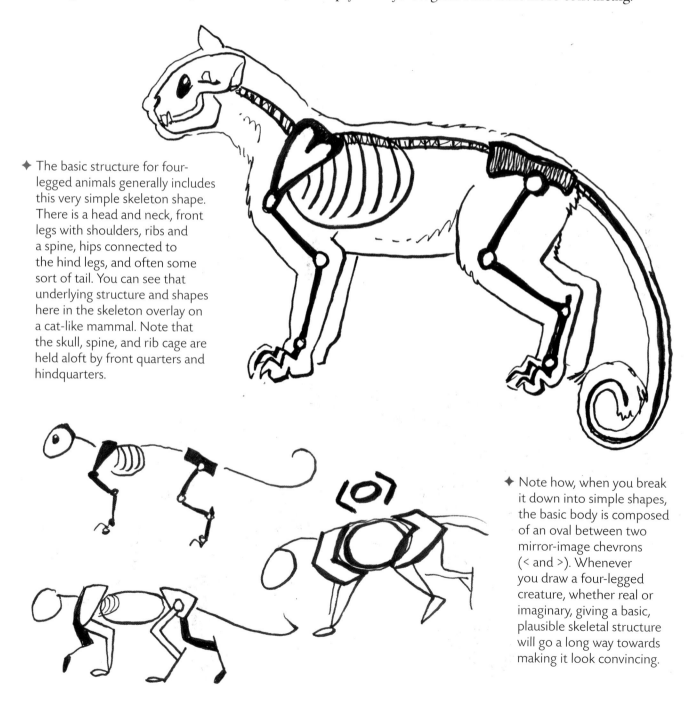

✦ The basic structure for four-legged animals generally includes this very simple skeleton shape. There is a head and neck, front legs with shoulders, ribs and a spine, hips connected to the hind legs, and often some sort of tail. You can see that underlying structure and shapes here in the skeleton overlay on a cat-like mammal. Note that the skull, spine, and rib cage are held aloft by front quarters and hindquarters.

✦ Note how, when you break it down into simple shapes, the basic body is composed of an oval between two mirror-image chevrons (< and >). Whenever you draw a four-legged creature, whether real or imaginary, giving a basic, plausible skeletal structure will go a long way towards making it look convincing.

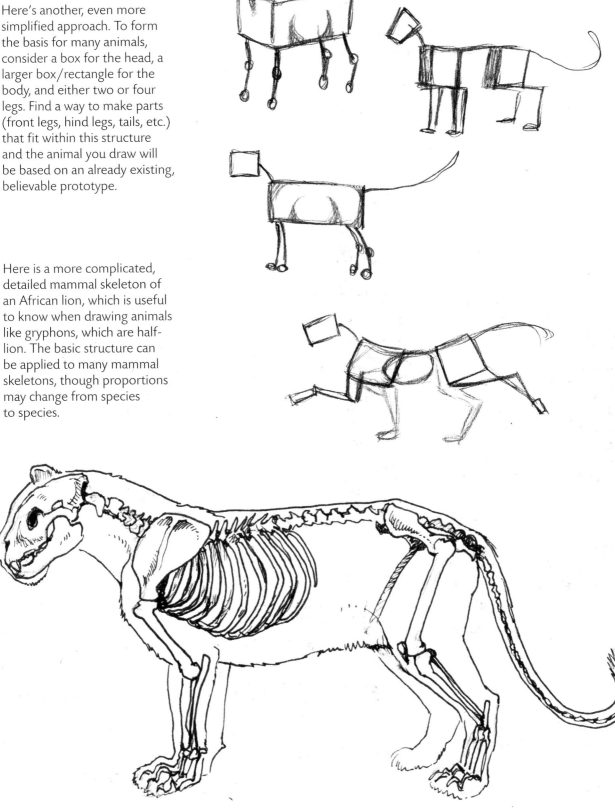

✦ Here's another, even more simplified approach. To form the basis for many animals, consider a box for the head, a larger box/rectangle for the body, and either two or four legs. Find a way to make parts (front legs, hind legs, tails, etc.) that fit within this structure and the animal you draw will be based on an already existing, believable prototype.

✦ Here is a more complicated, detailed mammal skeleton of an African lion, which is useful to know when drawing animals like gryphons, which are half-lion. The basic structure can be applied to many mammal skeletons, though proportions may change from species to species.

REPTILES

Reptiles are also four-legged but their legs can be more squat or angled in appearance. Here are some tips on drawing reptilian creatures.

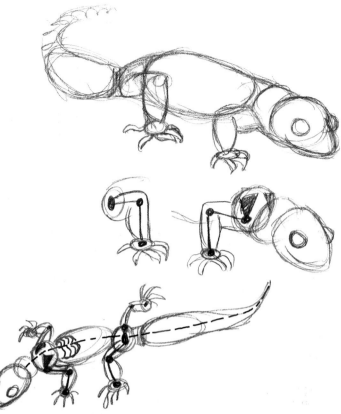

✦ When drawing a dragon or similar creature, it's good to know some basic reptile anatomy, since dragons are most often depicted with reptilian traits. One trait (especially of lizards) is their rather squat legs. They push out somewhat horizontally from the shoulder or hip and then right angle downward, palms flat on the ground, like this leopard gecko's legs. The top drawing shows some basic, blocked-in body-part shapes. In the middle and bottom drawing, I added very simplified indications of shoulders, bones, and joints in all four legs.

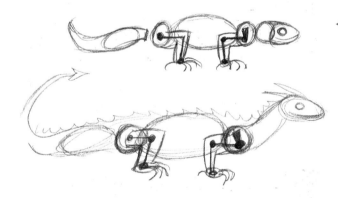

✦ I simplified the lizard/gecko's form even more in the top drawing. Note the large oval shape for the body and two almost mirrored images on either side—one is the hip circle and hind leg angled forward and the other is the shoulder circle and front leg angled back. At the back end is the tail (which has an oval shape at the base) and on the front end is the head and neck (consisting of a circular or tubular shape), and a wedge-shaped face. On the bottom drawing I expanded and exaggerated those basic shapes to create a dragon. The same basic form and reptilian shape is there, but now with a much longer neck, tail, and face.

✦ This leopard gecko's body (right top), when simplified (at bottom), breaks down into various shapes. At left, there is a circular shape for the head, a cone-like snout, and a neck that can be simplified into smaller circle. On the right side is the oval of the main body itself. Somewhat compressed between those two main shapes is the front leg, which looks a bit like a triangle sandwiched between the neck and body. A very angular leg extends from the triangle (shoulder), jutting just behind and then down to rest on an oval-like front foot with toes. In the middle drawing, see how you can use this information to inform a dragon illustration by exaggerating these features. I added ears, horns, more noticeable nostrils, and a longer muzzle to the same basic gecko shape. It's the start of a fantasy creature grounded in reality.

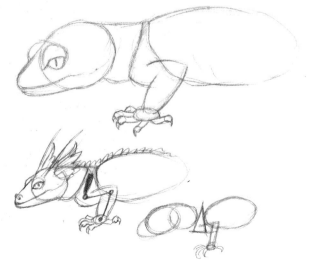

16

✦ Note how this bearded dragon's foot, like many lizards', consists of a circular or oval base with about five tubular toes extending out from it, each tipped with a sharp claw. Many lizards have smaller outer toes with three inside toes that are longer.

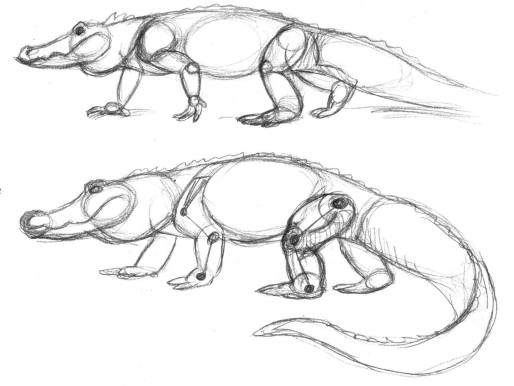

✦ Take a look at some of the larger, more powerful reptiles and study their anatomy. Their larger heft and weight means they tend to have thicker legs and more pronounced muscles. I sketched some alligators (top two) and then their skeletons and muscles (bottom). Note how massive the thighs are. Their legs can also appear slightly straighter sometimes as they move their bulk across a surface.

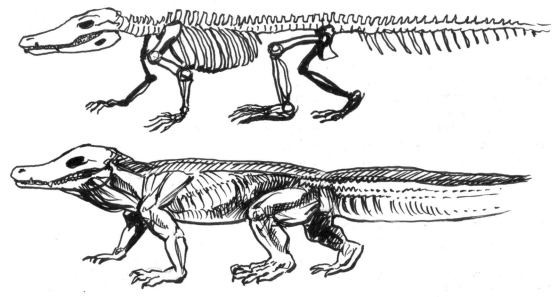

Tables and Springs

This advice doesn't apply to all animals but it is a good rule of thumb when trying to convey a sense of lightness or heaviness in your creature's body. Larger animals, especially mammals, tend to have a lot of weight to support and thus, like tables, have fairly straight, muscular legs. Think of an elephant, moose, or a muscular horse. Smaller animals' legs don't support as much weight so they can be more bunched under the body, ready to jump or run. Heavier animals may look a bit like tables, straight-legged and sturdy, while smaller animals may be more hunched and spring-like.

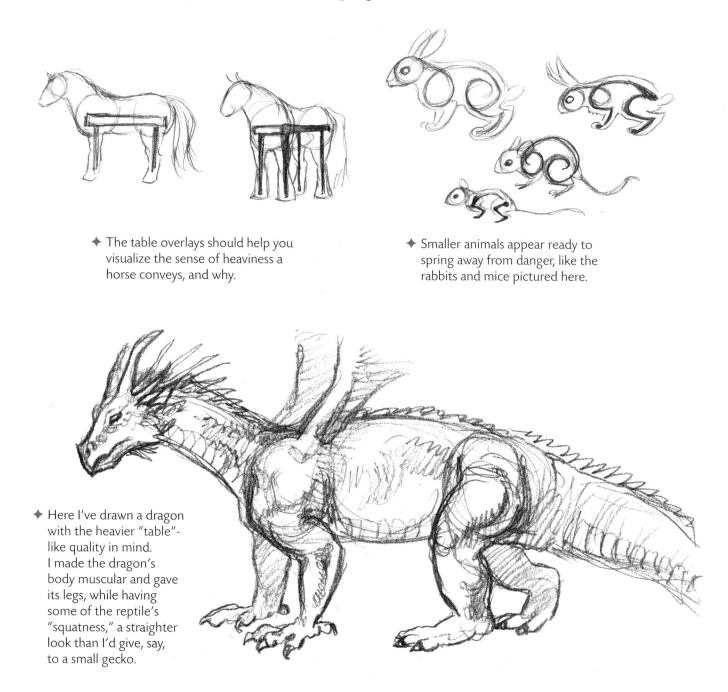

✦ The table overlays should help you visualize the sense of heaviness a horse conveys, and why.

✦ Smaller animals appear ready to spring away from danger, like the rabbits and mice pictured here.

✦ Here I've drawn a dragon with the heavier "table"-like quality in mind. I made the dragon's body muscular and gave its legs, while having some of the reptile's "squatness," a straighter look than I'd give, say, to a small gecko.

✦ The table overlay makes it easy to see how the dragon's weight is fairly evenly and solidly distributed.

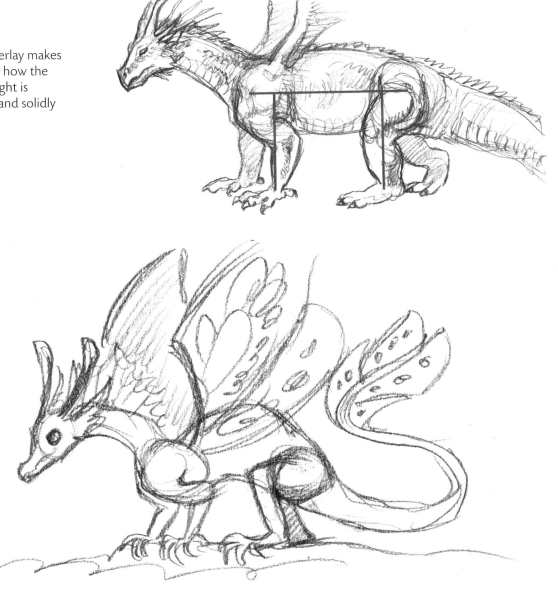

✦ Here is another dragon, probably more of a fairy dragon. It is small, delicate, and I drew its body more hunched and ready to spring into flight for safety.

✦ Here I highlighted some of the curved, spring-like shapes of this small dragon's body.

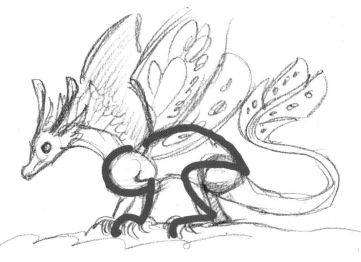

Adding Weight and Character to Basic Shapes

These drawings reveal the basic shapes within the animal that will help you visualize and understand how to successfully convey a sense of weight in the creatures you draw.

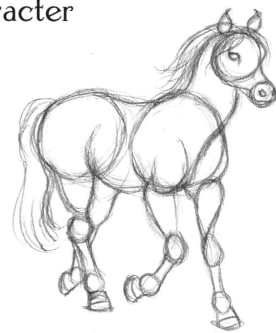

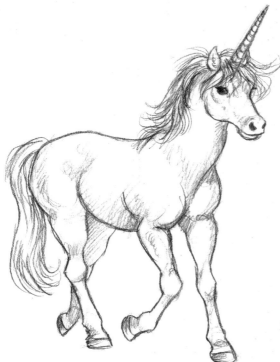

✦ There are near-limitless approaches to drawing a unicorn. The most typical involves drawing what is basically a horse and then sticking a horn on its head. (Or wings, if drawing a Pegasus.) Here is a basic horse shape, a good starting point for your typical unicorn.

✦ I added a horn to the head, cleaned up the lines, and TA DA—a unicorn!

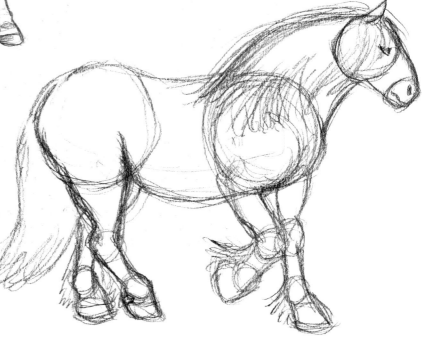

✦ But drawing a standard horse with a horn is not the only way to draw unicorns. Try something that is horse-based, but less typical. Here I sketched a heavyset horse I saw in real life that had long feathering (tufts of hair) around the legs, which can make an attractive addition to any creature design. You can exaggerate them, add them or other long strands of hair wherever you like, on the body, the tail, and/or mane. It's interesting to play with different body types for any creature. Try one that is more heavyset, or skinnier, than you usually draw and see what the results are.

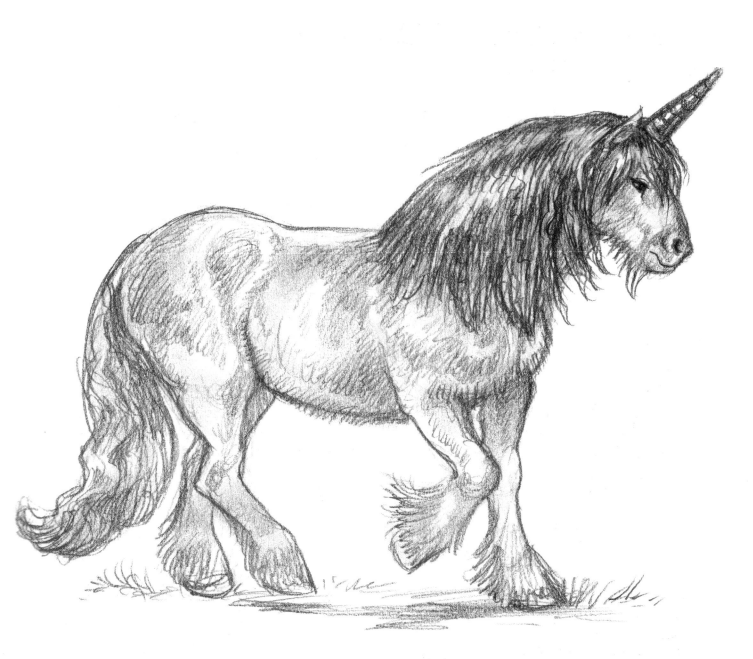

✦ Here's the finished drawing. Since the horse is strong and heavyset, I decided to make its horn strong and thick, too. Look for ways to echo one theme throughout your drawing, like making all parts of the creature thick and heavy, or thin and springy, or sharp and cutting. This is not a rule set in stone, but having common themes (including shapes, texture, color, lines, etc.) can help unify your drawing.

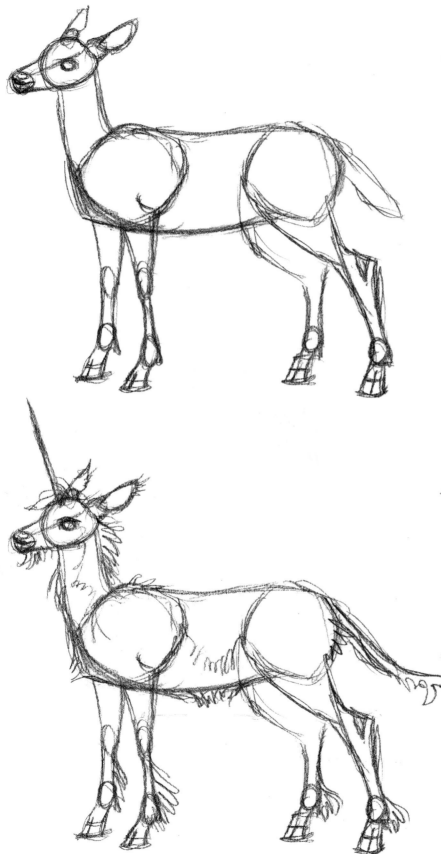

✦ A basic horse shape isn't the only way to approach drawing a unicorn. While unicorns are generally seen as having a four-legged body with hooves and a horn, other aspects of their anatomy are more open to artistic interpretation. Traditionally, they have been depicted as horse-, goat-, or deer-like. I took a more deer-like approach here, so this unicorn is more slender than the previous ones and its neck is much slimmer than the arched, thick, horse-like necks of the previous unicorns. The hooves are split like a deer's not singular like a horse's, and it has dewclaws (small hooves that don't quite touch the ground, located behind and above the main hooves). Its eyes and ears are comparatively larger in relation to its head than a horse's are.

✦ I added details to transform this deer into a unicorn—first a horn, of course (a slender one) and then a slight mane. I added tufts of hair on the legs, body, and tip of the tail and a "beard" on the chin, and elongated and thinned the tail. I went with a unifying theme of keeping everything about this animal slender.

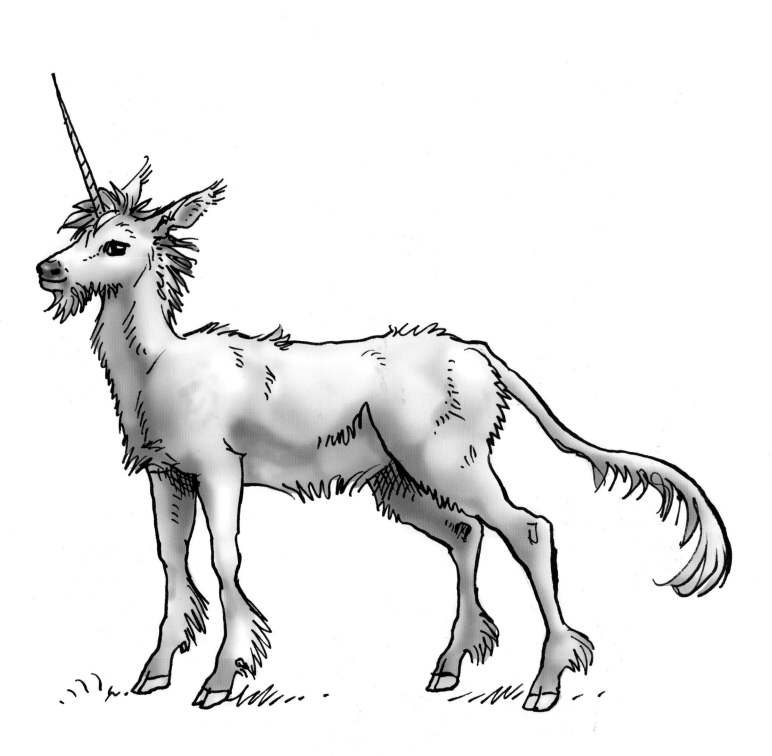

✦ The finished drawing, colored in.

✦ In this drawing I combined both deer- and horse-like elements. I wanted the arched, muscular neck of a horse but on a slightly more slender animal. The body I've drawn is very horse-like but slenderized, and the hooves are split like a deer's. It also has comparatively larger eyes and ears than a horse and its tail has long hair only on the bottom half. I combined two animals into an original creature using my own artistic tastes as a guide, choosing features from each that I liked. I included some basic skeletal structure in the drawing to show that the body has to be put together in a way that looks anatomically believable.

✦ Here is the finished unicorn, possessing both horse-like and deer-like traits. I drew the horn fairly slender, like the rest of the animal, and added tufts of hair where I wanted to.

Two-Legged Animals

Non-human animals that stand on two legs are probably best known and represented by birds.

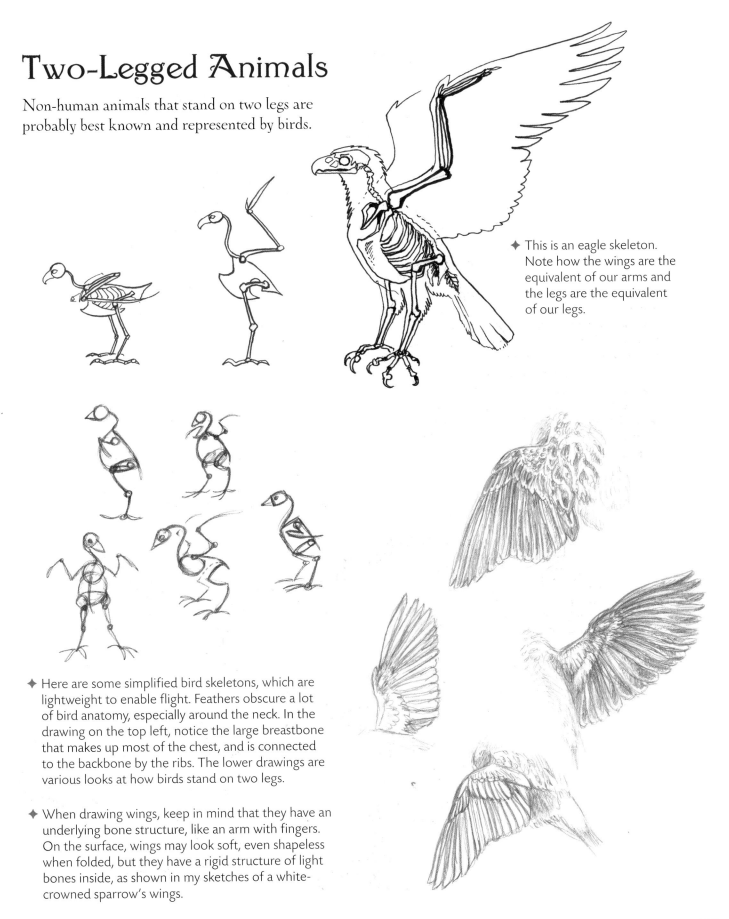

◆ This is an eagle skeleton. Note how the wings are the equivalent of our arms and the legs are the equivalent of our legs.

◆ Here are some simplified bird skeletons, which are lightweight to enable flight. Feathers obscure a lot of bird anatomy, especially around the neck. In the drawing on the top left, notice the large breastbone that makes up most of the chest, and is connected to the backbone by the ribs. The lower drawings are various looks at how birds stand on two legs.

◆ When drawing wings, keep in mind that they have an underlying bone structure, like an arm with fingers. On the surface, wings may look soft, even shapeless when folded, but they have a rigid structure of light bones inside, as shown in my sketches of a white-crowned sparrow's wings.

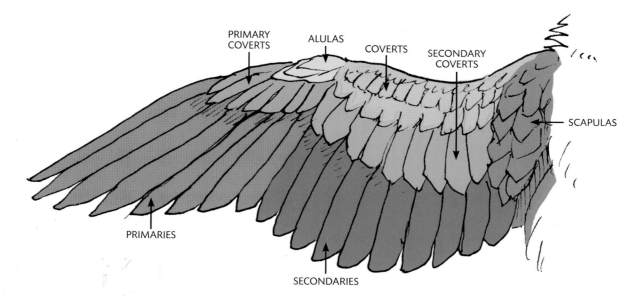

PRIMARY
COVERTS

ALULAS

COVERTS

SECONDARY
COVERTS

SCAPULAS

PRIMARIES

SECONDARIES

✦ Wings consist of several sets of different feathers, each of which have a specific role in helping the bird fly. Here is a top view of a wing, showing some of the various types of feathers. Each color highlights a different set of feathers. The pointy red feathers at the tip of the wing are the primary feathers (that are a bit like human fingers). The long ones shown in dark blue are the secondary feathers. The purple feathers between the main part of the wing and the body are called the scapulars. The yellow feathers at the top left are the alula feathers and cover bone that is a bit like the thumb of a human hand. The other, shorter gold feathers are covert feathers, which cover the top part of the wing. The blue feathers in the middle are secondary coverts and the green middle feathers are primary coverts.

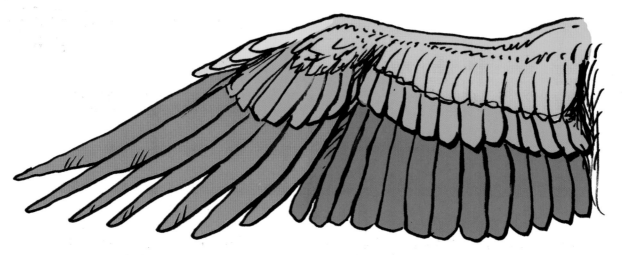

✦ Here's a view of the underside of the same wing, showcasing some of the larger sets of feathers. The color guide is the same as for the topside of the wing (the previous image).

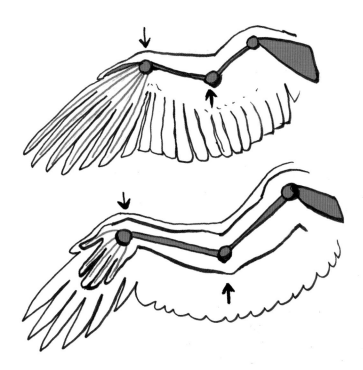

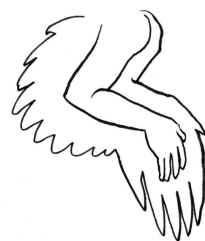

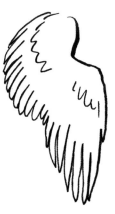

✦ Understanding wings will help you in drawing any mythological creature that flies. Wings can be thought of much like human arms. Here I've placed bottom arrows at the "elbows" on both a wing and an arm and put top arrows at the "wrists" of both.

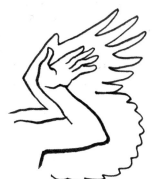

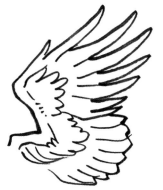

✦ A few sketches demonstrating how to visualize a bird's wing using human arms as a reference (above).

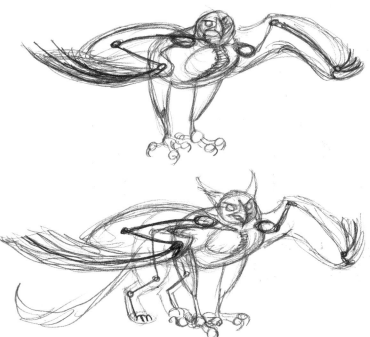

✦ Studying wings will definitely help you make your drawings of flying creatures look better. Here I drew an eagle (top) and then, using the same basic shape, added and changed a few features to turn it into a gryphon (bottom).

Combining Creatures to Make New Ones

A lot of mythological creatures are based on a combination of animals. The key to combining them in your drawings successfully is to make that mesh of creatures look believable. Of course, understanding anatomy is key here. The more you know about the animals the creature is based on, the more convincing your creature will be. After that come choices based on personal taste and style. It can be fun to combine elements and see what emerges from the page!

Let's look at a few mythological creatures to see how I blended the body parts and features together.

GRYPHON

The gryphon is a classic example of combining two real animals, an African lion and an eagle, to create a mythological one. (See skeletons for a lion on page 15 and an eagle on page 25.) So how does an artist combine these two animals convincingly? With a gryphon it's close to a 50/50 blend, with an eagle-like front half combined with a lion-like back half. Usually shown as a four-legged animal with wings, its most basic shape draws heavily from the lion's body. Because the gryphon is a four-legged animal, I approached it more like a lion at first, keeping that eagle-like front with wings in the back of my head as I drew.

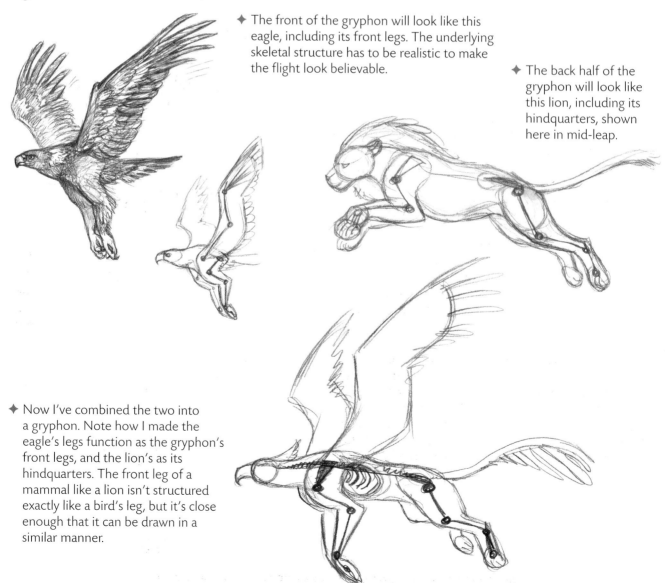

✦ The front of the gryphon will look like this eagle, including its front legs. The underlying skeletal structure has to be realistic to make the flight look believable.

✦ The back half of the gryphon will look like this lion, including its hindquarters, shown here in mid-leap.

✦ Now I've combined the two into a gryphon. Note how I made the eagle's legs function as the gryphon's front legs, and the lion's as its hindquarters. The front leg of a mammal like a lion isn't structured exactly like a bird's leg, but it's close enough that it can be drawn in a similar manner.

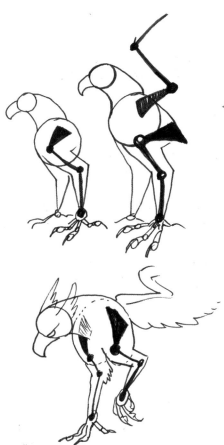

✦ On the top right is a simple bird shape showing the basic bone structures of wings and legs. Ignoring the wing for a moment, note how the bird's full leg isn't massively different from the front-leg bone structure of the creature at top left. They aren't the same, but they are similar enough to give some artistic license. This is the leg structure I used in the bottom drawing of a gryphon. It's very bird-like in the front portion, though I've drawn the structure of the legs more like the front legs of a mammal complete with shoulder blades, but with bird's feet. Ultimately, it's very subtle. The finished gryphon's front half would look very bird-like on the surface but the mammalian frame underneath, especially around the shoulders, helped me connect this front half of its body with the spine and back half for a whole, four-legged animal that looks convincing.

✦ Here I'll give a tip on the way I approach drawing a gryphon. With a fantasy creature such as this, there is no real wrong way to approach drawing. There are basically two things at work, structure-wise, when I am drawing a gryphon. One is that I think about the underlying anatomy to try to make a creature that looks like it has weight and the ability to move. The other is more artistic. I want to draw something cohesive and seek to place lines on the page or screen in a manner that is ultimately pleasing to the eye and easily understood by the viewer. For instance, here I've shown what I imagine the basic underlying structure of a gryphon would be along the shoulders where the wing joins the body. Perhaps the wings connect to the body right above the shoulder blades.

✦ Artistically, this sketch is more graceful and simple to understand. Many of the lines I've drawn depict the outline of body parts flowing easily into other parts. The line depicting the front shoulder sweeps up to the top of the wing. My approach to drawing mythological creatures generally consists of both wanting them to appear anatomically correct and artistically pleasing. Your approach may rely on both or favor one or the other.

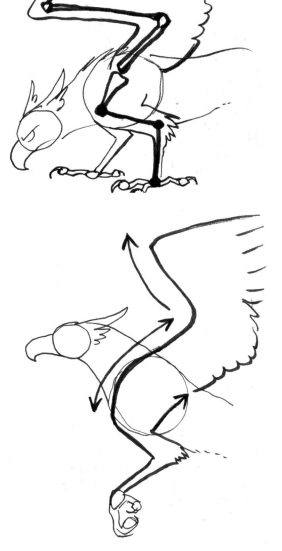

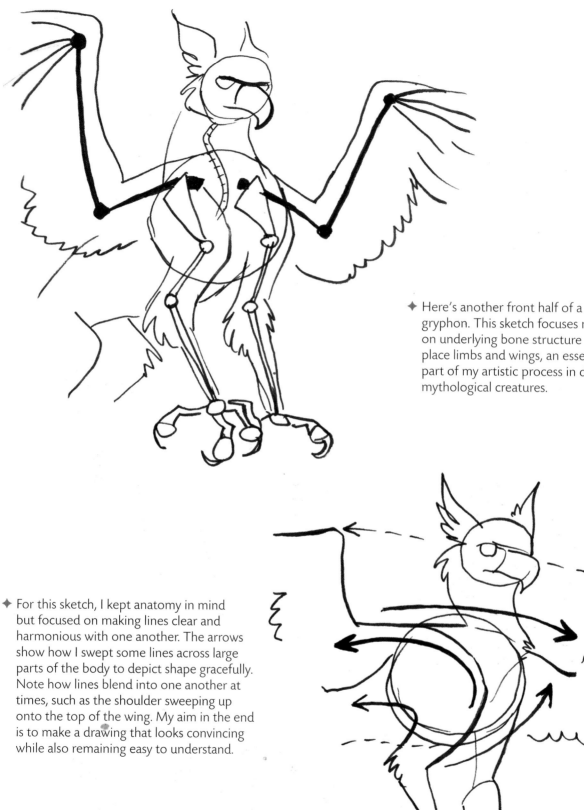

✦ Here's another front half of a gryphon. This sketch focuses more on underlying bone structure to place limbs and wings, an essential part of my artistic process in drawing mythological creatures.

✦ For this sketch, I kept anatomy in mind but focused on making lines clear and harmonious with one another. The arrows show how I swept some lines across large parts of the body to depict shape gracefully. Note how lines blend into one another at times, such as the shoulder sweeping up onto the top of the wing. My aim in the end is to make a drawing that looks convincing while also remaining easy to understand.

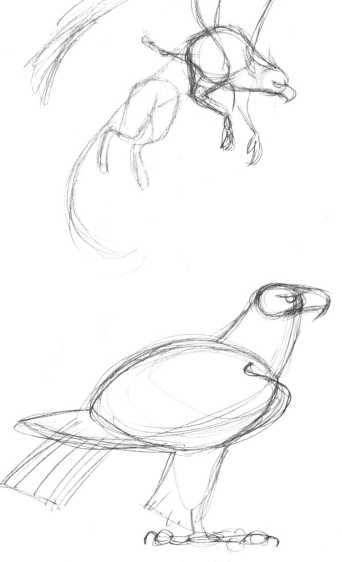

◆ Here's an eagle drawing and a gryphon drawing based on it. Note how similar they are, even though I gave the gryphon more massive shoulders and changed the placement of the wings a tiny bit to put them directly above the shoulders of the front legs.

◆ There are other little adjustments, too. Here is an eagle (right top) with the gryphon it's based on below it. Even with a lion's hindquarters added to the rear, the eagle's basic form (minus its tail) is still intact, but I made a few changes. I made the body (now the gryphon's chest) comparatively smaller and its wings larger so that the wings look like they cover more of the entire body. I figure this creature needs large, powerful, wide-reaching wings to lift its body into the air.

DRAWING A DRAGON

A mythological creature usually has a basic, standard "look," but since it's a fantasy animal, nothing is really set in stone. Take dragons. The standard dragon is usually reptilian, with scaly, lizard-like features and maybe a set of bat-like wings. You might want to experiment sketching various types of dragons or even make up your own. Perhaps you envision a dragon that has features inspired by other real-life animals that you like. I've seen dragons based on animals like cats, salamanders, birds, even insects. (See the section on fairy dragons on page 68.)

◆ I decided to go with a cat-like dragon. The cat (top) has big eyes, pointed ears, tufts of hair on the cheeks and body, and a general slinkiness of the torso. I drew the dragon (below) with those characteristics in mind. Instead of cat's whiskers and facial tufts, I drew spike-like appendages, feelers perhaps, on the dragon's cheeks. The ears are similar, the dragon's just slightly enlarged with added tufts. The dragon's nose is fairly short like the cat's, though I retained the overall reptilian/dragon shape. I gave it a slinky pose like the cat's stance. Similar attitude and poses can convey aspects of the inspiration animal in your creature. The long, almost fur-like spikes along the back and tail are reminiscent of the cat's fur. I gave the dragon retractable claws like a cat's, so I drew thicker toes with slits on the end where the claws are retracted. All these features give the dragon a cat-like aspect that is a little different from the usual reptilian dragon one sees.

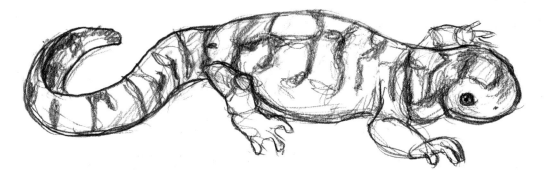

✦ Here we have a tiger salamander. If I wanted to draw inspiration from this salamander for a dragon species, I'd note its features first: big, round, almost puppet-like head; long body and tail; squat legs with thick forelegs; and slightly webbed-looking feet.

✦ I drew that basic dragon shape again, blocking in the basic head, body, and tail shapes and proportions.

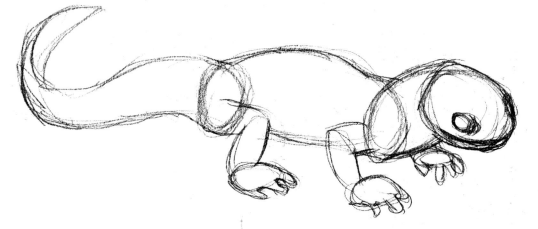

✦ Next I added legs. However, I made them just a bit sturdier-looking than the more splayed legs of a salamander (but not too much; I still want that "look" of a salamander). Then, I blocked in the rest of the basic body shape.

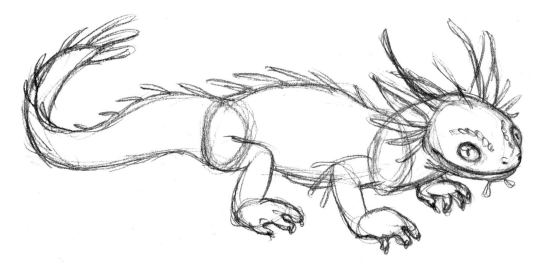

✦ I added details, including dragon-like features: ears, whiskers, and various fin-like spikes.

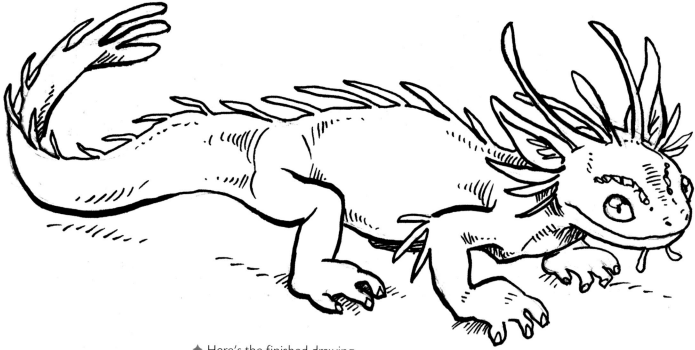

✦ Here's the finished drawing.

Drawing Feet, Claws, and Scales

Here are a few lessons and step-by-step drawings and demonstrations to help you draw some of the essential features of several mythological creatures, from dragons to gryphons.

FEET

Drawn feet generally consist of a circle or oval for a base and toes extending from that base. For mammal-like paws, the toes tend to be shorter and rounded, whereas for birds and reptiles, they tend to be long, tubular shapes with joints and claws or talons. Many mammals have four or five toes, plus a dewclaw (small vestigial toe on the inner side and slightly up from the foot, placed a little bit like a small thumb). It has a small claw and paw pad. There's also often a small paw pad behind the wrist joint above and behind the foot. (This all varies by species, however.)

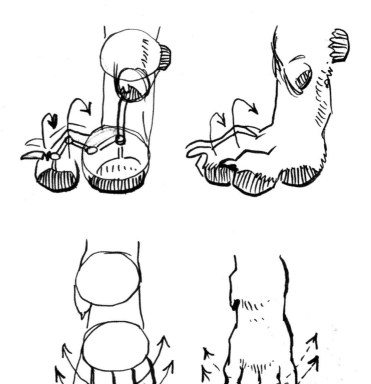

✦ Here I drew some dog feet, with somewhat "pinched"-looking toes tapering to a distinctive, clawed point. Note how there are joints within the toes (the curved arrows depict where the joint juts upwards, then down, and where the toes meet the claws and tips).

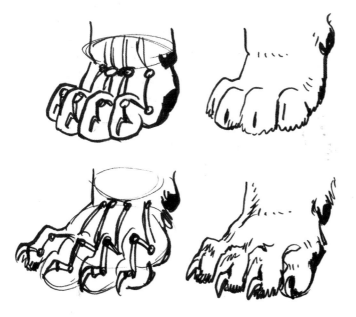

✦ Here are some lion feet. Also a mammal, the lion has feet that are larger and broader than a dog's. Note how the structure is similar, except for the retractable claws. Retractable claws can be pulled inside the paw into a sheath where they are protected and not visible to the eye, and then extended out of the paw/sheath for gripping, climbing, killing, or defense.

STEP-BY-STEP LION'S FOOT, FRONT VIEW

 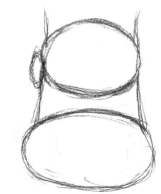 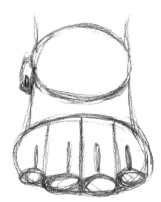

1 This exercise will help you understand how to draw a lion's hind feet, as well as many other mammalian paws. First draw two ovals, one on the bottom (base of foot) and a slightly smaller oval above it for the wrist, with a small distance between them.

2 Connect the base and wrist ovals with outlines of the lion's outer foot. Add a smaller oval shape on the left side (inside of leg) connected to the wrist joint for the dewclaw.

3 Add toes by drawing three evenly spaced, vertical lines (one directly in the center and two on either side). Draw a small circular shape on the bottom of the dewclaw for its paw pad.

4 Place the paw pads by drawing ovals on the bottom of each toe, then add claws, or the slits in the skin that the retractable claws are sheathed in. Draw the claw on the dewclaw.

5 Finish the drawing, inking or otherwise placing the final lines while erasing the unneeded lines you used to block the foot in. As you finish the final lines, feel free to indent slightly on the top and bottom where each toe meets the other; this will create an extra sense of three-dimensionality.

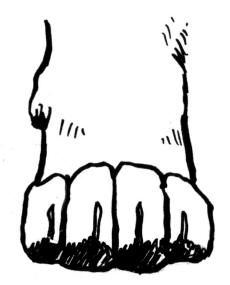

STEP-BY-STEP LION'S FOOT, THREE-QUARTER VIEW

1 First draw two circles, one above and slightly behind the other. This will be the base of the foot and the wrist just above it.

2 Draw the outline of the toes, which can be blocked in with a somewhat curved, almost oval, rectangular shape. Jut it out in front of the base circle, not quite reaching the back end of that circle. Then draw a smaller circle under the wrist circle, and behind it, for the dewclaw. Connect these joints and parts together with the front outlines of the foot.

3 Now draw three slightly curved lines to indicate the four toes, leaving the closer toe with the largest visual space (since you see more of that toe because it's closer). Draw a curved line on the dewclaw to indicate the small paw pad there. Connect all the foot parts together with outlines.

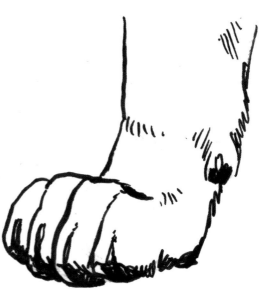

4 Draw small ovals on the very bottom of the toes to indicate paw pads, which are just visible. Add the claws, or the slits in the skin that the claws are sheathed in, on the tips of the toes (including the dewclaw).

5 Finish the drawing by placing final lines (ink in this case) and erasing unneeded pencil lines. You can use scruffy, zigzag lines where the hair on the toes meets the paw pads to give the toes a furry feel.

REPTILIAN OR BIRD FEET

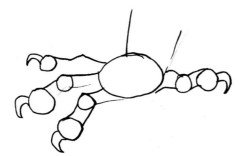

✦ Here are a few drawings of feet that could easily be used on a reptilian creature like a dragon or perhaps a bird-like animal like a gryphon. Giving the foot a thumb makes it seem more akin to a human's hand, which can work for creatures like dragons but is ultimately up to the artist. Note how the toes are tubular with large joints and thick claws at the end. There are two joints in the toes themselves, as well as joints (knuckles) where the toes join the foot.

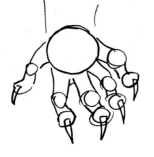

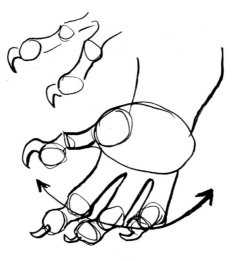

✦ Here's a closer look at one of these reptile or bird-like clawed toes. I've used arrows to indicate the main thrust of the lines. Note how where the toe would press down against the ground, I've drawn thicker, wider lines to indicate how "smooshed" that part is. The base of the foot and the bottom tip of the toe is where the weight is and I use broader, more horizontal lines to indicate that. Note also the rounded knob of the knuckle where the toe meets the foot on top right.

DRAWING TOES ON A DRAGON'S FOOT

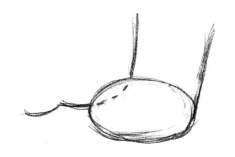

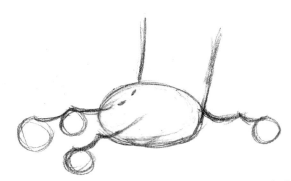

✦ First I drew an oval shape for the base of the foot, and two lines to indicate the leg. The left leg line continues down from the front of the leg, then out, in a broken line to indicate the middle toe (there will be four toes total, three in front and one in back). The line sweeps up twice, once for the middle knuckle and the second time where the tip of the toe will be.

✦ I added more to the middle toe by drawing a circle for the tip, then used the first wave point in the middle of the toe to place a circle for the joint. I drew the tops of two other toes, one in front of the middle toe and the toe extending to the back of the foot. Note how I drew the top of the back toe extending from the top of the oval of the foot's base. I drew circles for the tips of the toes on each.

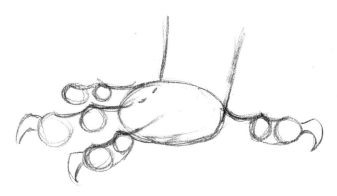

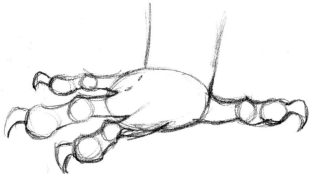

✦ I added the rest of the toes, drawing circles for joints and tips and generally starting from the top. I connected the joints together on the closer toes and added claws. Note how the furthest toe's top line sweeps to meet the top of the foot.

✦ Here, I finished the outlines of all the toes, connected the joints and tips, and drew claws.

✦ To finish the drawing, I inked the lines in and erased the pencil lines.

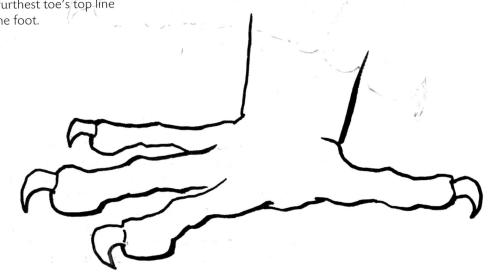

DRAWING SCALES

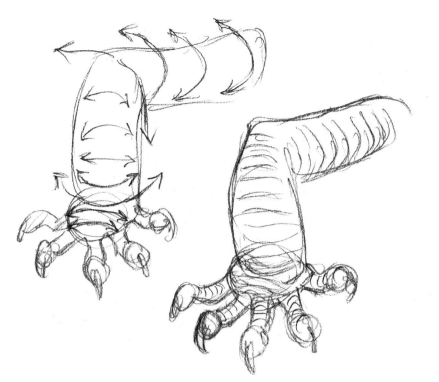

✦ On the left, I've drawn arrows indicating how the scales one might draw will circle around the leg's shape. To depict the three-dimensional leg, the scales won't fold around it in a flat line, they will bend around the leg, following its curves. On the right, I've replaced the arrows with guidelines I'll use to help me draw the scales.

✦ I added wavy lines over the guidelines to depict scales wrapping around the leg's form, and more square-shaped scales to the top parts of the toes only (for now). Reptilian and bird-like toes can have especially thick, plate-like scales on the top part of the toe.

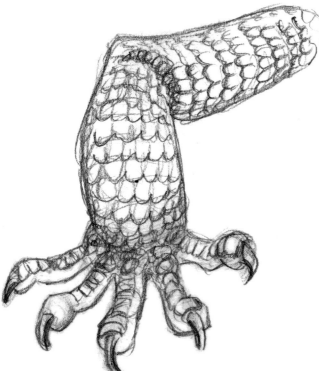

✦ Going back over each row of scales, I refined them and added more detail. I left a less defined area towards the top where I imagine light hitting the arm might make it appear shinier. When I got to areas where scales folded on top of one another or were otherwise compressed against each other, I often used small, circular scribbles to make the scales seem small and dense. I went over and clearly defined the tops of the toes with large scales and made sure they connected to the foot, blending with normal scales there. Darkened lines on the bottom of the claws add shadows and the appearance of depth.

✦ To finish the drawing, I began shading the leg, using small sketchy lines to darken areas that might be slightly in shadow. In this case I didn't worry about the individual scales, shading over them as needed. I also lightly shaded along (but not on) the blank highlight "stripe" on top of the leg, which adds a little contrast to the blank whiteness and makes it pop a bit more. To finish the toes I darkened the claws more, leaving blank highlights on top of the nails. I also added detail to the bottom half of the toes, using scribbles, some wrinkles, and indications of circular scales. The top toes have the big, thick, almost square-like scale shapes. The bottoms are fleshier with smaller scales and more easily bent.

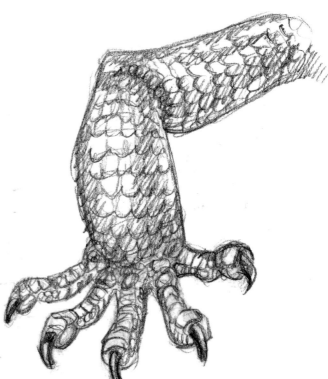

2
Dragons

Dragons have long captured the human imagination. Many cultures all around the world have their own variation of a large, powerful reptilian with fearsome teeth and claws. Some dragon-like creatures are good, some evil, but all tend to possess great powers. Dragons in Western cultures have historically been fire-breathing, winged, and are often destructive and aggressive. Dragons in Eastern cultures have tended to be intelligent, wise, wingless, and considered symbols of good fortune. Whether good, evil, or in between, dragons command attention whenever they appear. Today, a dragon might appear almost anywhere and be any size. They are magical and mystical and an artist can use his or her imagination to create almost any kind of dragon they can think of. In this chapter we'll look at various dragons and similar creatures from around the world and explore creating your own.

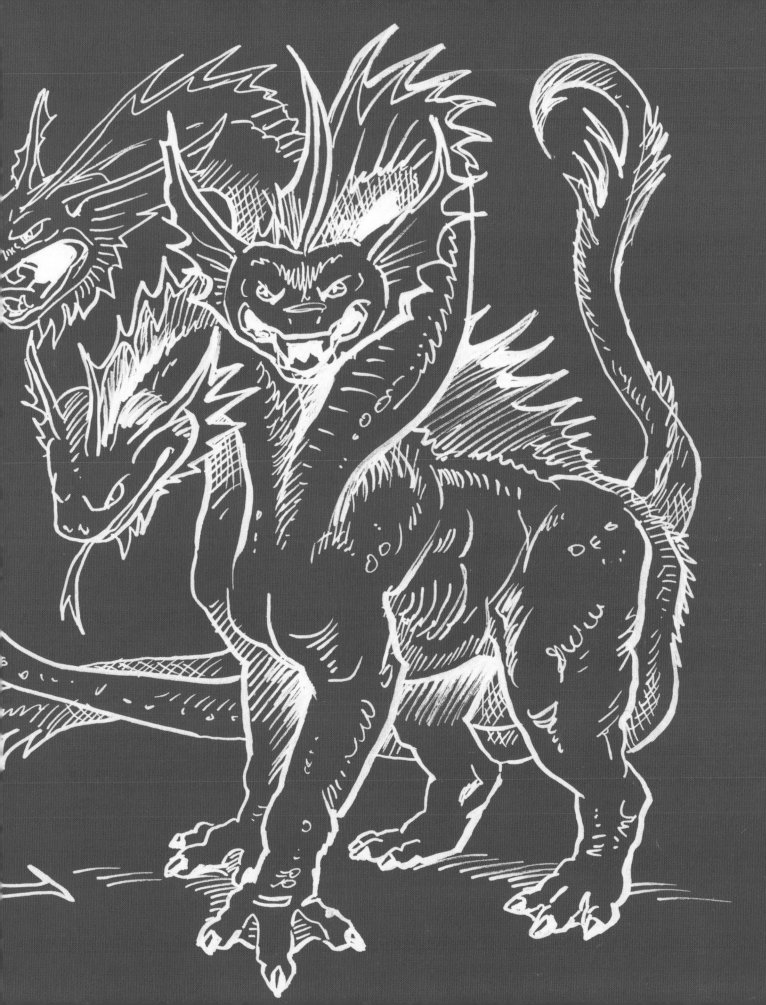

Basic Dragon Features

Here we'll look at how to draw some basic parts of dragon anatomy and tackle some simple step-by-step drawings.

STEP-BY-STEP DRAGON EYE

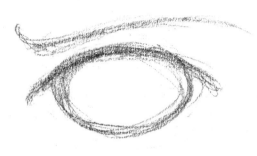

1 Begin by drawing an oval for the eyeball. Add a curved line arcing over the top to indicate the eyelid (and tear duct, which is on the left side of the eye here). Draw a scooped checkmark-like line above the eye for a furrowed "eyebrow," leaving a little space between it and the eyeball.

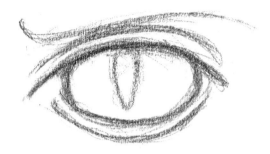

2 Add a cat-like pupil (almost teardrop-shaped, narrow, vertical) with a tapering edge on bottom and wider top meeting the eyelid above it. Draw curved lines around the eyeball to indicate the upper and lower eyelids.

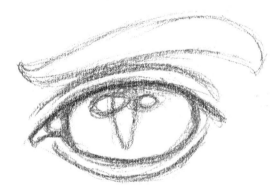

3 For the highlights in the eye, add two circles, one large and overlapping the pupil, and a smaller one on the other side of the pupil. Keep a little space between them and the upper eyelid. Add a tear duct on the left side; if you were drawing the dragon's entire face, its muzzle would be off on the left. (I made the tear duct slant to almost a tip, then slightly flattened the tip. Then I added a smaller circle inside for a moist highlight.) Finally, add a sweeping line above the eyebrow line you already drew. This is where the scaly "eyebrow" will go.

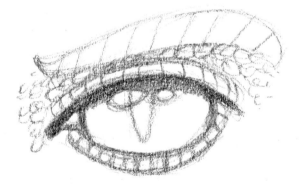

4 Begin to add scales using circular shapes or ovals around the eye. Use either ovals or slightly curved horizontal lines to add scales on the eyelids themselves. Add slightly slanted horizontal lines on the "eyebrow" that lean to the right, away from the tear duct. These will be bigger scales later. Shade the tear duct except for the highlighted ball portion. Add a shadow under the upper eyelid along the tops of the circular highlights, leaving them unshaded.

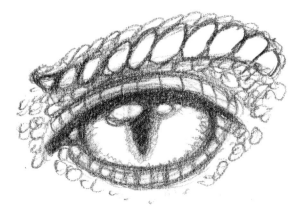

5 Now define the "eyebrow" scales, making each one almost egg-shaped and much larger than the ones that surround them above and below. Feel free to add another, smaller layer above. Add various small scales below the eye. Shade the tear duct further, leaving a softly shaded highlight showing some moisture. Shade the pupil and erase the extra lines within the highlights of the eyes. You may also add some slight, circular shapes and shading to the eyeball around the pupil and where the eyeball meets the eyelids.

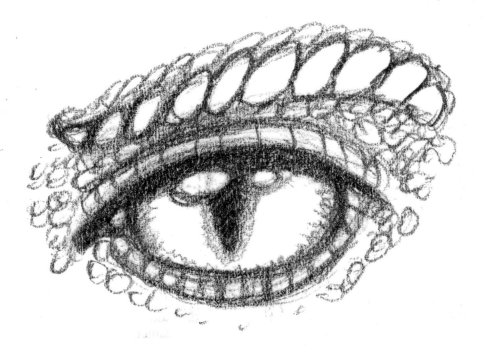

FRONT LEGS

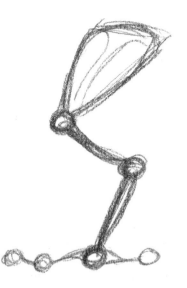

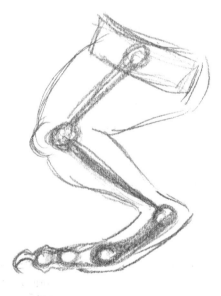

✦ Dragon legs are often depicted as rather reptilian and squat. Here's a basic stick-figure look at the skeletal structure of the dragon's front leg.

✦ I added more of the volume of muscles around the leg and details to the toes.

HIND LEGS

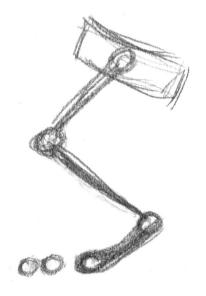

✦ Hind legs, like front legs, are fairly reptilian and squat. I made the dragon put more weight on the ball of its foot than the heel.

✦ Here I added more detail to the toes and the volume of muscles around the leg.

STEP-BY-STEP CARTOON BABY DRAGON

1 This will be a simple, cartoony baby dragon. As with most young creatures, its head is much larger in proportion to its body than an adult's would be. Draw a circle for the baby dragon's head. Then add a smaller circle underneath, slightly overlapping the first circle. This will be the chest. Draw a bean-like shape, placing the narrow end at the top of the chest circle, just under the head. Draw the bottom of the bean wider and bent slightly back to the left. The bean will be the dragon's body.

2 Draw horizontal and vertical guidelines on the face, to the right of center and curving slightly to the right. The baby dragon will be looking slightly to the right, so the face will be in three-quarter view. Add a teardrop-shaped ear on the left side, joining the head circle just above the horizontal line, giving it a wider base at the bottom and narrow tip at the top. For the belly, draw a smaller, slightly curved oval shape inside the bean.

3 Add a line towards the top of the ear, dividing the inside of the ear from its back. Draw three lines indicating a tuft on the ear tip. Draw the dragon "bangs" from the right side of the ear across the top of the head. Add two circles along the upper horizontal line on the head for the eyes. The baby dragon will be sitting in half an eggshell, so draw a semi-oval under the dragon's body (leaving room at the bottom for its legs and a tail). Draw the top of the eggshell half curving slightly across and behind the dragon's body.

4 Draw pupils in the eyes and more hair-like spikes on the back of the head. Draw an oval underneath the eyes for the muzzle. Add a tuft of scaly "hair" inside the ear. Draw the edge of the eggshell closer to the viewer, curving it down in the middle, so the dragon looks like it's sitting in a teacup. Render the arms, extending down from the top of the chest. The line of the back of each arm should curve with the top of the chest circle. The line of the underside of each arm curves and meets with the oval you drew for the belly, as shown.

5 Add highlights to the pupils (broad ovals on the top of the eyeball). Add a mouth and nostrils on the muzzle. You can add two more scales on the top of its head, behind the ear, and perhaps a few down its back. Then draw ovals at the ends of each arm for the hands. Draw the tail, making it come to a point, and then draw an upside-down heart shape on the end.

6 Just for reference, I included the basic shapes of the dragon's legs here (which are hidden by the eggshell in the drawing) so that you may have a better idea of what the dragon's entire body is doing.

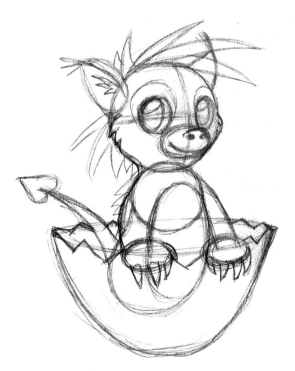

7 Add claws to the dragon's hands and a curved line above the nostrils to indicate the top of the nose. Draw the other ear, letting it overlap the "bangs." You will draw the bangs overlapping the more distant ear later. Add details like scales on the cheeks (which should be located on either side of the muzzle just below the horizontal dividing line). If you wish to have something similar to eyebrows, add larger circles around the eyeballs. Finally, add the jagged edge of the eggshell, letting lines dip below and above the "teacup" edge you drew earlier.

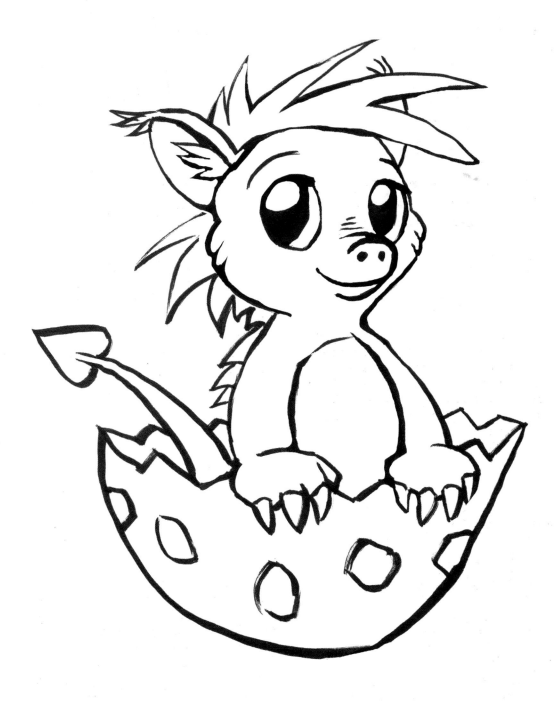

8 Clean up the lines and ink or pencil in the final drawing. Add whatever details you choose, such as spots on the eggshell.

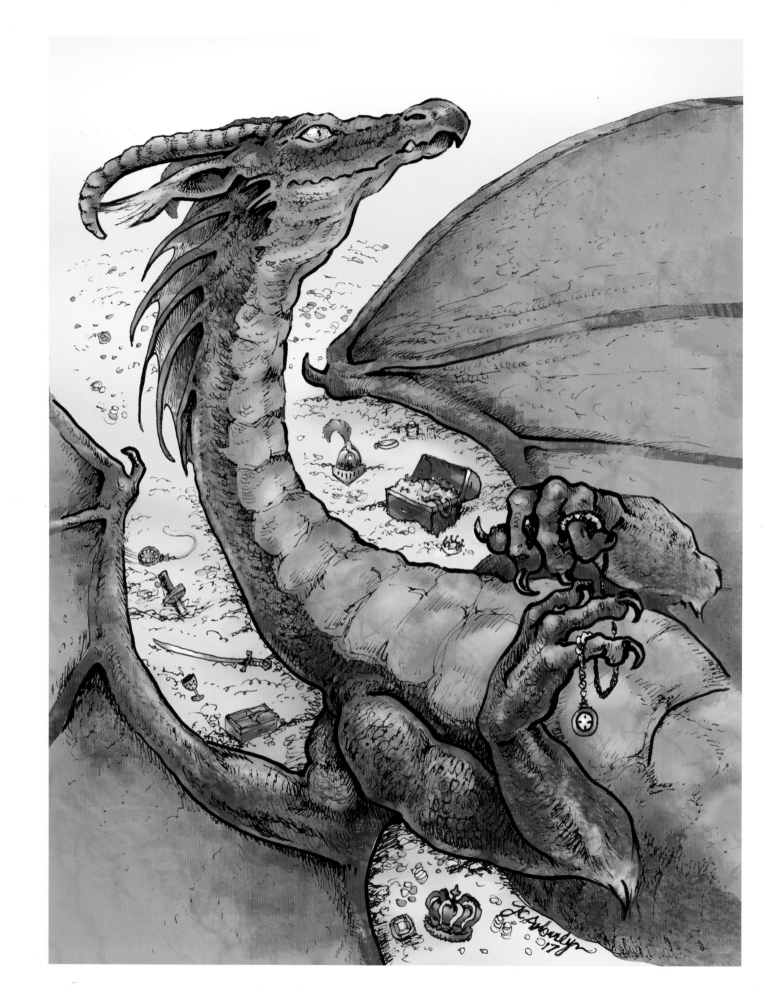

Western Dragons

The Western, or European, dragon is the scaly, horned, bat-winged, fire-breathing antagonist of many a European fairy tale or fantasy role-playing game. It eats livestock and often people, too. Great heroes and heroines are fated to dispatch the dragon and save a village from its reign of terror. This dragon loves to hoard treasure in its hidden lair, in a castle or cave. Today, some artists and writers are retelling these legends from the dragon's perspective. Maybe sometimes the dragon isn't so bad and just wants to protect its riches from greedy, treasure-stealing humans?

STEP-BY-STEP SIMPLE DRAGON HEAD, FROM THE FRONT TOP

1 Draw a circle; divide it into quarters with horizontal and vertical lines. Center a smaller circle below the first, but not touching it. Extend the center vertical line down through the center of the smaller circle (which will be the nose), dividing it into halves.

2 Connect the head and nose with curved lines. Begin with a sharply curving line at the outside end of the horizontal line. Continue down the face in a less sharp curve as it finally meets the center of one half of the small snout circle, as shown. Draw teardrop shapes for the nostrils. Add two teardrop shapes for the ears just above the horizontal line of the big circle.

3 Now add eyes in the lower halves of the larger circle, using the arcing lines from Step 2 for the top part of the eyeballs. Draw horns on the top of the head. (I added marks here to indicate where I made the horns slightly thicker and more angled as they curve inwards, connecting them on the skull with that curved line. I made the blank space between the horns an egg shape.) Add the outside top of the ears where the bases of the ears meet the head. Next draw the outline of the snout, keeping it thinner than the main part of the head. Finally, add a slightly sharp tip to the nose on the bottom.

4 To finish, add pupils in the eyes. (I drew cat-like pupils.) Erase the back part of the head between the horns. Draw some lines indicating webbing inside the ears and perhaps add a little tuft to their tips. Erase lines that are not needed anymore, but keep some of the lines you drew connecting the corner of the eyes to the nose. You can add bumps above the nostrils to indicate fleshy protrusions.

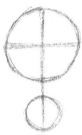

OPPOSITE: A Western dragon lies upon its vast hoard of treasure, reminiscing about glorious days gone by.

STEP-BY-STEP DRAGON, WHOLE BODY

1 Draw two equal-sized circles, aligned horizontally with about a half-circle of space between them. This will become the dragon's chest (left) and hips (right). For guidelines, sketch two parallel horizontal lines at the bottoms and tops of the two circles, and a third line one circle height above these two circles.

2 To draw the neck, extend an S-curved line up from the outside of the chest circle (left), curving out and then in, as shown. Draw a small circle at the end of this line for the head (the top of this small circle should hit the topmost guideline). Draw a similarly curved line to indicate the back of the neck, extending from the back of the head circle and curving to meet the center top of the chest circle. Connect the chest and hip circles by drawing a slightly curved back at the top, and a line at the bottom for the belly. Add the back part of the front leg (curving around the back of the chest circle). Draw a small pie-slice shape on the back of the chest to indicate the elbow. Sweep down from the elbow and draw an oval for the front foot below. Draw the hind leg so the knee juts out left of the hip circle, as shown. Add the heel and an oval for the ball of the hind foot.

3 Now add the muzzle, keeping it about as thick as the head circle and rounded at the tip. Center a horn on on the head. Draw the front of the closer front leg. Next, sketch in the backmost front leg on the far left, extending down from the bottom guideline and at an angle to the chest circle. Leave space for the front foot. Draw an oval behind the closer hind foot you drew in Step 2 to indicate the backmost hind foot. Draw the tail, letting it curve and taper to a tip.

4 Draw a diagonal line to divide the dragon's head in half horizontally. Draw a parallel line closer to the top of the head. Use this second guideline to draw the nostril and the eye, placing the eye inside the head circle. Add the outline of a bat-like wing over the body, folding it back where it meets the top horizontal line, as shown. Divide the wing into three relatively even triangle segments. Draw a tuft on the tail, and finish the front foot and hind legs on the far side. Sketch smaller ovals atop the feet ovals. These will be toes.

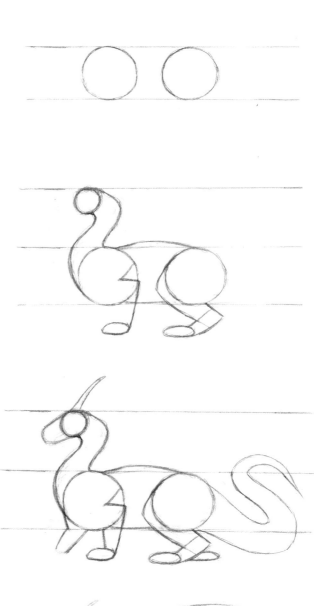

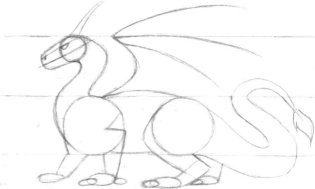

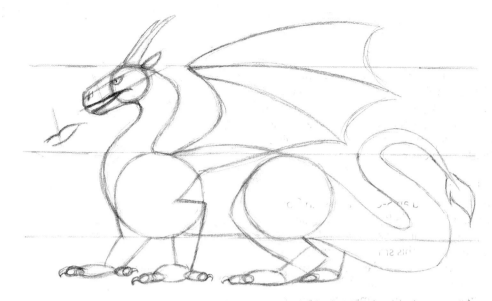

5 Add the mouth, using the horizontal guideline you drew in Step 4, which now divides the upper from the lower jaw. (Note that I gave this line a subtle curve, which I exaggerated in the little sketch placed next to the head). The mouth line dips down, then pulls back up, indicating a thickness in the middle of the muzzle's length. The mouth extends a bit past the eye, to which you can add a pupil. Add a teardrop shape for the ear along the back of the head, and the other horn. Complete the bat-like wing with curved arcs between each segment, ultimately connecting to the shoulder. On closer front and back feet, draw circles on the ends of the toes for joints, and add claws. You'll add more toes eventually, but work on the shape of the closer toes to begin with.

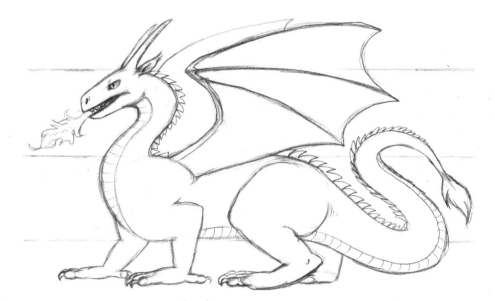

6 Now to finish the drawing. You can erase or lighten the lines you no longer need, then add details, including the rest of the toes on the feet (using the toes you've already drawn as guides). Draw teeth, a highlight in the eye, details in the ear and a tuft on its tip if you'd like. You can draw fire coming from the dragon's mouth. Add some thickness to the bat-wing segments and main base of the wing, then indicate the back wing. Finally, draw the line separating the belly from main body, then draw short, more horizontal lines to show the scales. Add pointy scales going down the dragon's back and broad scales on its neck. If you'd like, you can experiment, adding a longer or shorter muzzle, smaller or bigger or differently shaped wings, maybe more scales or longer horns, etc. There's a lot of variation you can explore.

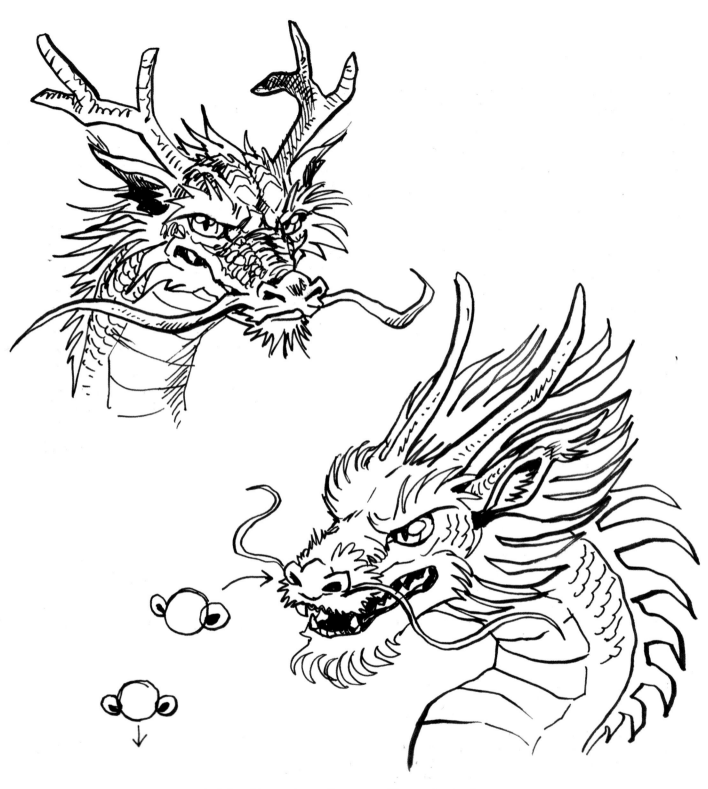

✦ Asian dragons have all manner of horns, bushy fur or scales as eyebrows, whiskers, sometimes small manes, and other decorations on their heads. They are frequently depicted with a sort of pug nose as shown, which can be blocked in by drawing a circle with two smaller circles on either side for the nostrils.

Asian Dragons

Asian dragons have long been revered as symbols of power, magic, and wisdom. Where Western dragons were often portrayed as evil monsters to conquer, Asian dragons have often been seen as wise and just guardians of people or places as well as sources of luck and prosperity. They can be divine beings with important connections to the heavens or bodies of water, with links to thunder, rain, and good fishing. Chinese dragons have been an important figure in art and stories for thousands of years, and Imperial Chinese dragons are associated with the Emperor.

In Japan, the dragon is known as Ryu. The King of Dragons, Ryujin, lives in a palace at the bottom of the sea made of red and white coral. His servants include fish, jellyfish, and sea turtles and he controls the tides with magical tide jewels. He is also the lord of snakes on land and possesses a range of powerful medicines, including some that ensure a long life. Korean dragons are much like Chinese dragons but they have longer beards. They also have 81 scales on their backs.

Japanese dragons are often portrayed with three toes, Korean and Chinese dragons with four, and Imperial Chinese Dragons with five toes. Korean dragons come in three types: the Yong, the sky dragon, the Yo, the ocean dragon, and the Kyo, the mountain dragon. All are powerful and impressive, with long, sinewy bodies and, unlike Western dragons, they usually do not have wings. They can have horns, long whiskers, and many tufts of hair, scales, or flames along their spines, legs, or around their heads. There is a tale in China of a man named Ye Gao who loved dragons so much he had their image everywhere around his house. A dragon heard of this and was impressed enough to descend from the heavens to see him, at which point Ye Gao ran for his life, terrified at the sight!

STEP-BY-STEP ASIAN DRAGON

1 Start by drawing the dragon's body and head. Draw a small circle for the head then draw what is basically a tube winding up in an arc, then down to a larger circle (for the chest). Continue the tube in another arc then draw another circle (same size as the chest, this time for the hips) and continue the tube up, down, and up again for the tail, ending at a tip.

2 Flesh out the head, adding a muzzle by drawing a smaller circle in front of the head circle and attaching it with two lines. The muzzle should be more slender than the main head circle. Add the closer front leg by extending the chest circle outline down, then angle it forward into an oval, which will be the foot. Draw the leg up to the elbow and back to the chest circle about midway. In preparation, extend the belly line forward in front of the chest to guide your drawing of the other front leg you'll draw in Step 3. Add an oval for the hindquarters, extending it down past the hip circle and looping back to the rear. Draw a tuft on the tip of the tail and scales along the spine.

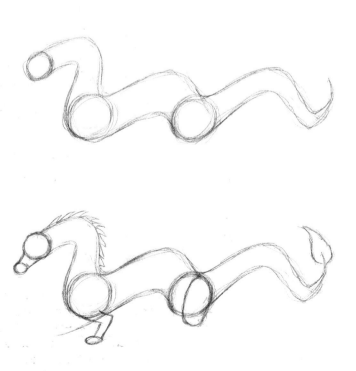

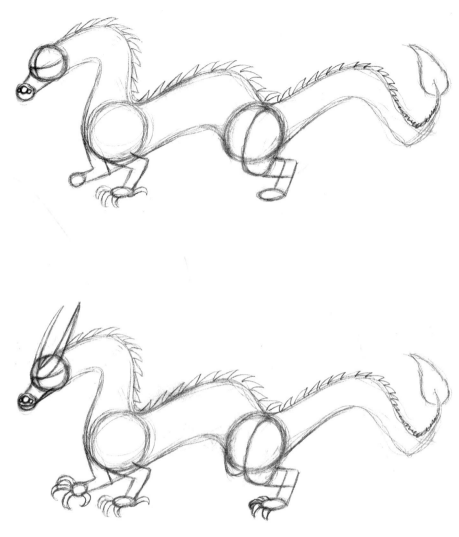

3 Finish the scales along the back. Go to the head and draw a couple of guidelines: a horizontal line that curves around the head towards the center of the neck, and a vertical line that curves along the left side of the head. This will be a three-quarter view of the dragon's head. Add the nose on the top half of the smaller circle of the head, drawing one circle and two smaller ones on each side for the nostrils. Draw four curved toes (three front and one back) on the closer front foot and use the guideline to draw the backmost front leg, extending out with another oval for a foot. Finish the hind leg, sweeping back to the ankle (making almost a square) and extending down to another oval.

4 Add horns. Draw the far horn sweeping up from the far side of the head; bring it back down to the vertical dividing line, then up again and back down to meet the horizontal dividing line of the head circle, as shown. Draw the mouth under the nose and extending down the muzzle. Add toes to the backmost front leg and hind foot, then draw the hindquarters of the backmost hind leg using the rest of the hip circle as a guide.

5 Now add the eyes along the horizontal dividing line. Add the whiskers on either side of the nose, and an ear (more flat on top and curved underneath) just under the horn on the side of the head. Complete the backmost hind leg, echoing the closer one and adding toes. Draw a line along the underbelly to indicate belly scales.

6 Add the other ear and some bushy eyebrows, using the head circle and horizontal dividing line as guides. Draw some cheek spikes and add some spikes above the horns. Define the toes further, adding claws, and draw some hair on the elbows. Use the tuft on the tail to guide you as you draw more flame-like hair.

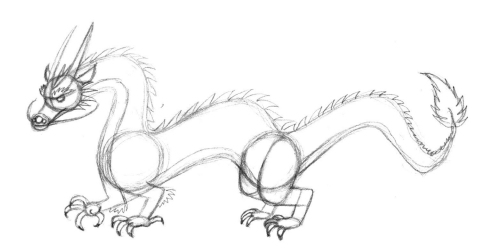

7 Finish adding details on the head, including the pupils in the eye and beard, more spikes along the jaw, and a small mane. Draw a line separating the inner and outer ear and add a tuft to each ear. Add the nostrils and emphasize the furrow of eyebrows between the eyes. Indicate each belly scale with some slightly curved lines.

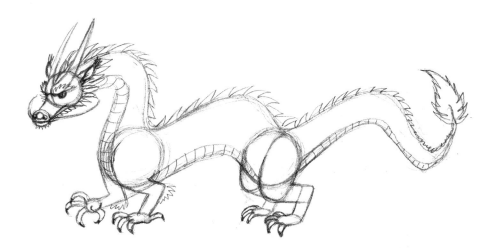

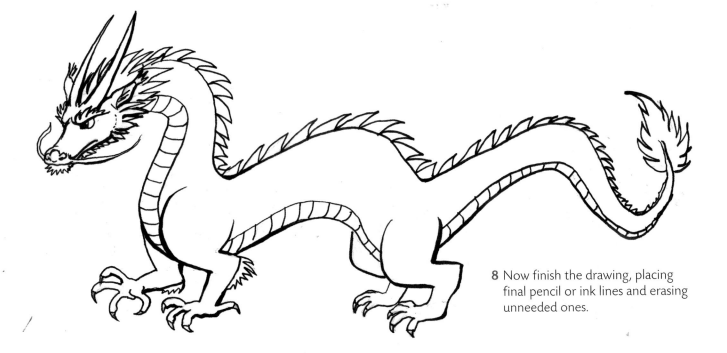

8 Now finish the drawing, placing final pencil or ink lines and erasing unneeded ones.

Quetzalcoatl

Quetzalcoatl is a Mesoamerican deity, sometimes represented in human form and sometimes as a feathered serpent. He has filled many roles in different cultures and was the god of many things, including wind, learning, books, the arts, science, agriculture, the inventor of the calendar, the bringer of rain clouds, and the one who gave humans maize (corn). Quetzalcoatl is linked to the morning star and the evening star (Venus) and conch shells, and is credited as a creator of humans and the world we live in, using his own blood to bring life to human bones. His feathered serpent form is a blend of earth and sky, a snake and a Resplendent Quetzal, which is a beautifully colorful bird of the region. It can be considered an allegory to the dual nature of spirit, sky up above and earthly beings on the ground below. This form is depicted with a large, showy crest of feathers around his head and a plume of feathers for a tail. He is usually mostly green in color (much like a Quetzal) and without wings.

✦ Quetzalcoatl's head can appear rectangular and blocky. Note the spiral shape behind his eyes.

✦ Here's a sketch I did while looking at ancient Aztec art, attempting to get a feel for the patterns I saw. Artists will interpret what they see in their own unique ways, but when drawing a mythological figure it is useful to pay attention to the region or culture the creature comes from. Your art will improve as your understanding does.

✦ Here's a Quetzalcoatl head in three-quarter view. I drew this based on Aztec stone sculptures of Quetzalcoatl and other snake-like creatures.

✦ Quetzalcoatl is sometimes depicted with an almost segmented body, one layer of feathers resting atop the next layer with some adornments or extra feathers sticking out. Artists may or may not choose to draw it this way.

STEP-BY-STEP QUETZALCOATL HEAD IN PROFILE

1 Draw a rectangle, then divide it into three equal horizontal sections. Draw two vertical lines, making three vertical sections with the middle section the smallest (this will be the eye).

2 Select the top left section. Working from the left, draw a slanted line about a third of the way from the left side, slanting down from right top to bottom left from the top horizontal line. Keep a small space on the between the slanted line and the left outside edge of the section. Draw a long horizontal line all the way across the top sections, about a third of the way up. This will be the brow line. In the same section, on the right, draw another slanted line from the brow line at the same angle as the first one. It should begin at the corner of the new horizontal brow line (not the very top line) and the vertical line in the center defining the eye area.

3 Draw an oval (for the eye) in the center top section under the brow line. Then, draw the long horizontal mouth, bisected by the lower horizontal guideline and tapering to a point in the middle of the far right section, as shown. The lines of the lips grow closer after they pass the left center vertical line, joining at the bottom third horizontal line.

4 Draw a parallel slanted line in the center of the upper left section, just a bit to the right of the slanted leftmost line you drew in Step 2. This pair of lines will be the nose. Draw a rounded shape for the pupil inside the eye. Then mirror the slanted line in front of the eye by drawing another slanted line behind it, leaning in the opposite direction and leaving space in the upper right section. Draw a zigzag line inside the mouth for the top teeth, leaving room for bottom teeth.

5 Inside the top left section, add a slanted-rectangle nostril to the nose you drew in Step 4. Its lines should slant like the lines around it. Go to the slanted line behind the eye and continue it, sweeping a spiral line down past the horizontal line that marks the underside of the eyeball and up and behind the eye. Draw the bottom set of teeth. Begin drawing the crest of feathers behind the head, starting with two curving feather shapes above and a single feather extending below the chin, lined up with the back side of the head rectangle.

6 Add the lips to the Quetzalcoatl. Draw the rest of the feather crest. The base of the two middle feathers should line up fairly well with some of the horizontal lines.

7 Finish the drawing. Erase lines as needed and draw in the final lines or ink the head and erase the pencil lines later. I added a highlight to the pupil and shaded the nostril, pupil, and between the teeth. Note that in finishing the head, I rounded some of the shapes of the outside rectangle. The nose, lips, and back of head in particular have some rounding to the corners now. I emphasized the brow above the eye, giving this Quetzalcoatl a stern, focused look. There were a few scale-like lines added behind the eye. Finally, I added a few lines in the crest feathers to indicate the feather shafts.

DRAW QUETZALCOATL IN COLOR (ADVANCED)

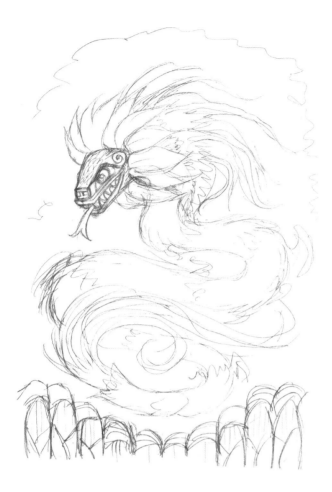

◆ **NOTE:** This isn't an exercise for beginners, but even if you are inexperienced, this demonstration may prove useful. You will see how I colored a traditional drawing using markers.

I first laid out the initial sketch on Bristol Board using a mechanical pencil. I wanted to show Quetzalcoatl bringing rain clouds to farmland, so I researched Aztec designs and found a corn pattern featured in Aztec artwork. The corn at the bottom is based on that design.

◆ I began by laying in the bright colors first. It's easy to muddy up bright colors when using markers, and I find that's less of a problem if I block in the bright yellows and greens first before tackling darker colors, which can dull the brights. I added some light red and blue to the head, neck, and tail. I wasn't sure what color the plume of feathers at the tip of the tail should be yet, so I left that blank. I blocked in the corn in basic yellow and green.

At this stage, I added some darker outlines, defining the basic shapes of the body and head. I layered darker red on top of the lighter red, and outlined areas like the spiral shape behind the eye and drew a stripe along the side of the body with it. To mimic Quetzalcoatl's depiction in ancient Aztec art, I segmented the body, making a layered look down its length, complete with feathers sticking out at an angle at each segment. I decided that with all the greens and yellows on the body, red would offer the highest contrast on the tail. So I first colored in yellow for highlights, then added blocks of red. I used light blue to begin defining the teeth and top shadow of the eyeball. Next I added details to the corn, outlining its silhouette, and colored in the sky with blue, leaving a blank white cloud billowing up behind Quetzalcoatl.

Here I used a black pen to outline things for the first time. (If you use a black outline and then color in with brighter colors, those colors can get muddy. So, when working with markers, I work from light to dark.) I added details, like more feathers, indicated the outlines of the teeth, and shaded in the pupil. (I also colored the yellow iris before adding the black.) Note that the base of the tail has an almost skirt-like cluster of blue, red, and then yellow feathers. This is based on some old Aztec drawings of Quetzalcoatl.

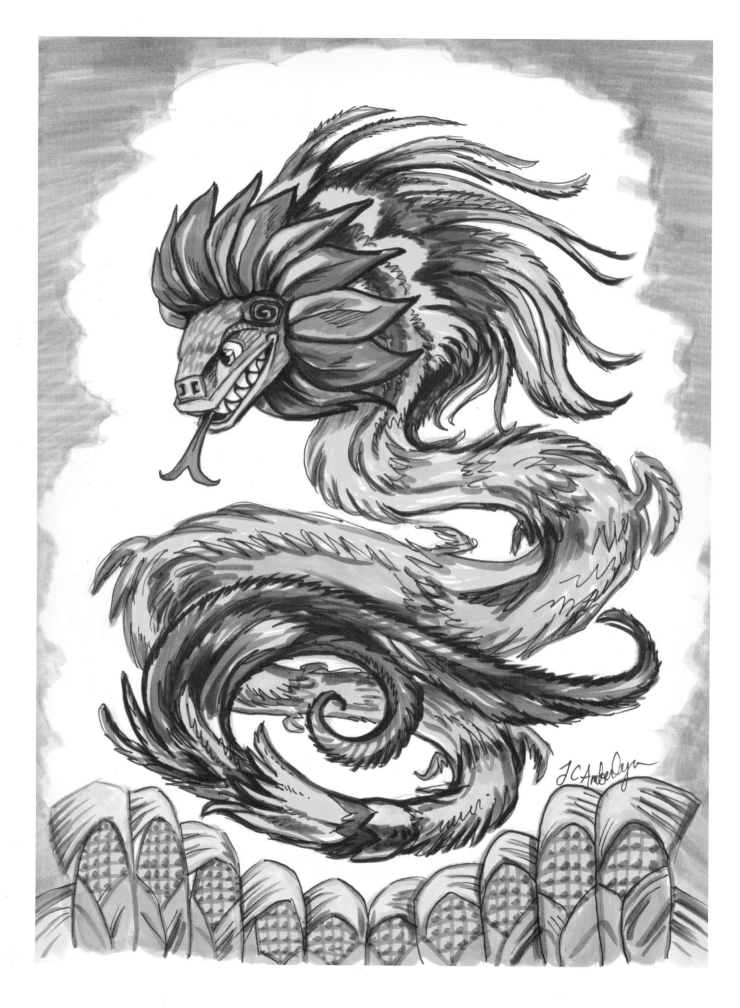

Sea Dragons

Ocean-dwelling dragons are known as sea serpents (or cetus, in Greek mythology). They appear as giant serpents, often with fish-like features, flippers, or other adaptations to the sea. It is possible they were inspired by the oarfish, a huge sea fish that could easily be mistaken for some kind of monster during its rare appearances near the surface. Sea serpents were known to attack ships at sea. Today, an artist can take inspiration from numerous real-life sea creatures when depicting their mythological counterparts.

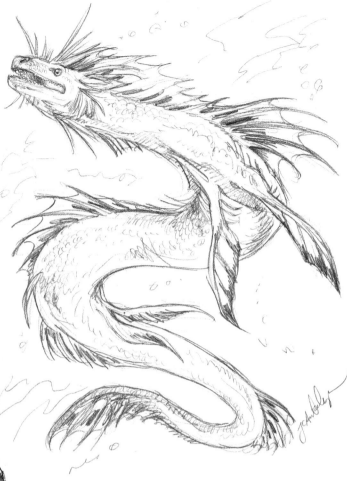

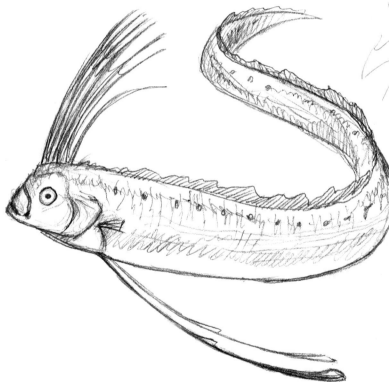

✦ A fairly traditional sea serpent has a snake-like body, fins instead of legs, and a head with dragon, fish, and eel-like features.

✦ An oarfish, believed to be one of the real-life animals that inspired stories of sea serpents, is the largest known bony fish (lengthwise), having been measured at 36 feet (11 meters) long and rumored to get even longer.

OPPOSITE: Here is the finished drawing of Quetzalcoatl. I felt the figure needed more solid shadows to add some weight and impact. The heaviest shadows and thickest black lines are on the head, crest, and tail. I realized that the shape and mass of the green body was a little too close to the shape and mass of the tail plume, so I broke up the body with some shadows and red markings. I also added more solid colors to his crest and more details to his face, using a black or brown marker. With the brown marker I added more shadows to Quetzalcoatl's body, as well as dots indicating shadows on the kernels of corn. Finally, I added my signature.

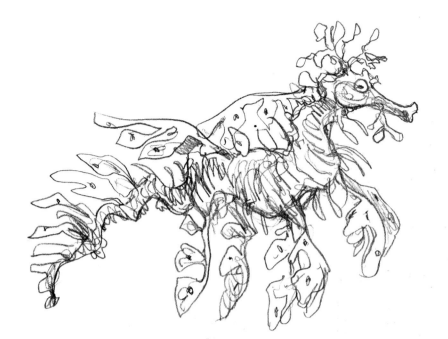

◆ This ornate, real-life fish is called a leafy sea dragon for its resemblance to the legendary creature. When drawing a fantasy sea-based dragon, or sea serpent, there are numerous real-life species one can take inspiration from.

◆ Another sea dragon design, this time with more fishy features added to a dragon-like shape. There are still some of the elements of a real-life sea creature.

CHAPTER **2**

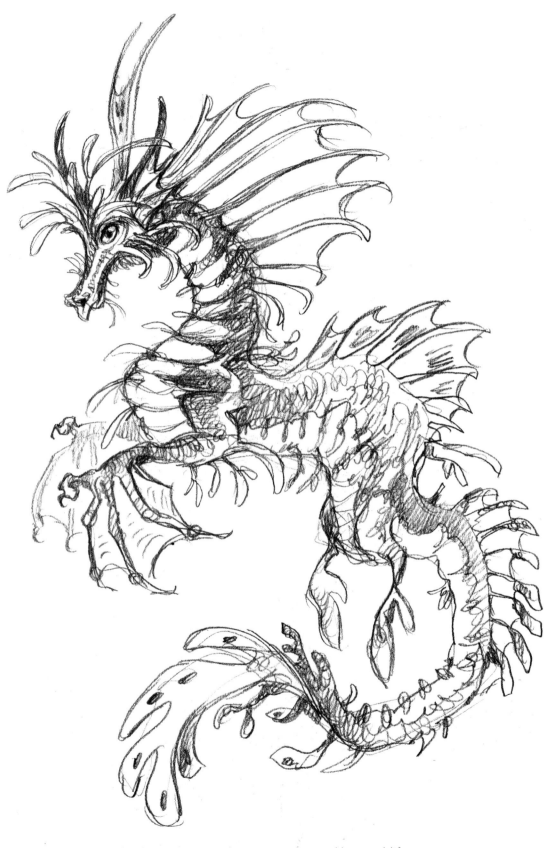

✦ This sea serpent drawing was inspired by a real-life sea animal. I gave it a similar head and body shape with some of the same leafy appendages. I added more claw-like front legs and fish-like fins on its neck and back.

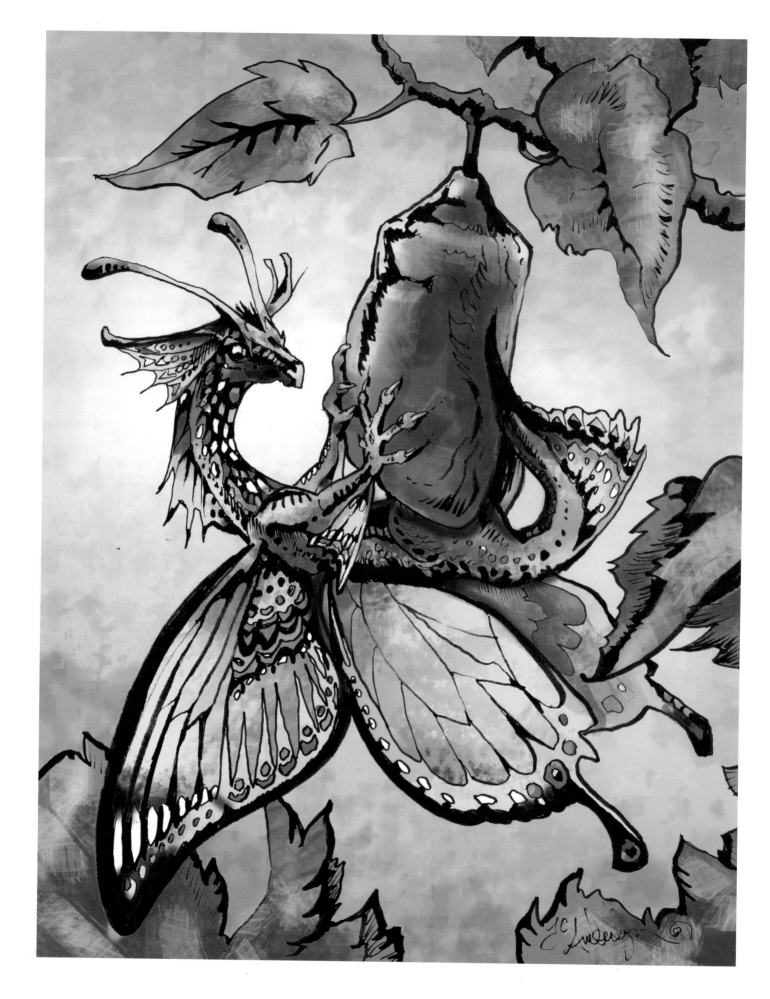

Fairy Dragons

Part of the fun of dragons is imagining all kinds of adaptations they might have made to a given environment. You can think of almost any animal (or plant, or maybe even something else) and combine it with something reptilian to create your own dragon species. One type of dragon produced from such imaginings is the fairy dragon. This is a tiny dragon often depicted with butterfly or other insect-like wings. It lives in a miniature world of insects and fairy folk, and tends towards mischievousness.

STEP-BY-STEP FAIRY DRAGON

1 Draw a long vertical oval for the body, then on either side, two larger wings on top and two slightly smaller wings on bottom. Getting the wings even can be a challenge. If you are drawing traditionally, a ruler will help. If you are drawing digitally, a grid, ruler, or some other measuring tool is useful. Whatever your medium, it is helpful to turn the drawing upside down to get a fresh perspective.

2 Block in the head, neck, and tail by drawing an S shape around the body. The top of the S should flow from above the right top of the body and curve back around and down the body's right side. The bottom of the S should hang down from the right bottom of the body, and loop to the left. Add a small circle inside the top part of the body oval for the chest.

3 Now add an oval-shaped head tucked at the top end of the S shape you drew in Step 2. Draw part of the neck, connecting the top left of the body oval to the back curve of the neck. Then draw the left side of the tail, connecting it up to the left side of the body oval. Draw the front feet tucked in towards the chest with two small ovals at the bottom of the chest circle. Finally, you can start the design motif of the wings. (I added a toothed rim inside the edges.)

OPPOSITE: Here I imagined a fairy dragon emerging from a protective cocoon.

4 Now add an eye inside the head oval near center but a little bit forward. Draw a slightly curved V shape to its right for the antennae. Fill in the rest of the neck, adding a line for the throat. Draw a webbed tail tip and two ovals on the bottom of the body oval for legs. Draw the arms folded behind the front feet by adding two curved lines under and to the outside of each foot, and then sweep them up and inward. Add more details to the wings. Feel free to experiment and create your own patterns or shapes.

5 Add a large pupil to the eye and draw tapering, rounded ends to the antennae, and a mouth. Draw slightly curving lines on either side of the antennae that echo the antennae, though they curl up at the tips towards the right. These will be the tops of the ears. Let the ear line almost, but not quite, meet the line of the mouth. Add toes on the front feet, and draw the hind feet tucked under the legs. Add more details to the tail.

6 Draw a highlight in the eye and webbed ears and a nostril. Add toes on the hind feet, and finish adding details to the wings and tail.

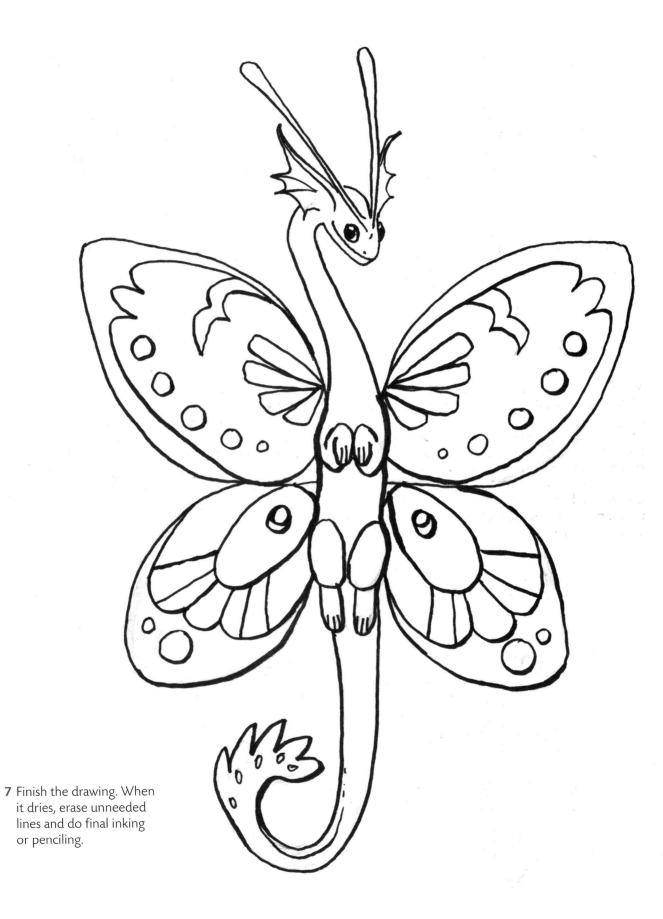

7 Finish the drawing. When it dries, erase unneeded lines and do final inking or penciling.

Hydra

The Hydra is a many-headed serpent-like creature, most famous from Greek myths. In the Greek tale, the heroic Hercules kills the nine-headed Lernaean Hydra as one of his Twelve Labors. When he cut off each head, two would grow back in its place. With the help of his nephew Iolaus, Hercules figured out that cauterizing the cuts with fire prevented new growth. When Hercules cut off the monster's center head, he killed it. The Hydra could spit acid, exhale toxic gas, and had venomous blood (which Hercules later used to kill another monster).

✦ The Hydra was a fearsome creature to fight against. Some Greek art shows the hydra heads with some sort of beard-like appendage and a snake-like body.

✦ Other depictions of the hydra are based on a dragon-like body. It always has multiple heads and may have multiple tails. This is a preliminary sketch I did of a more dragon-like creature.

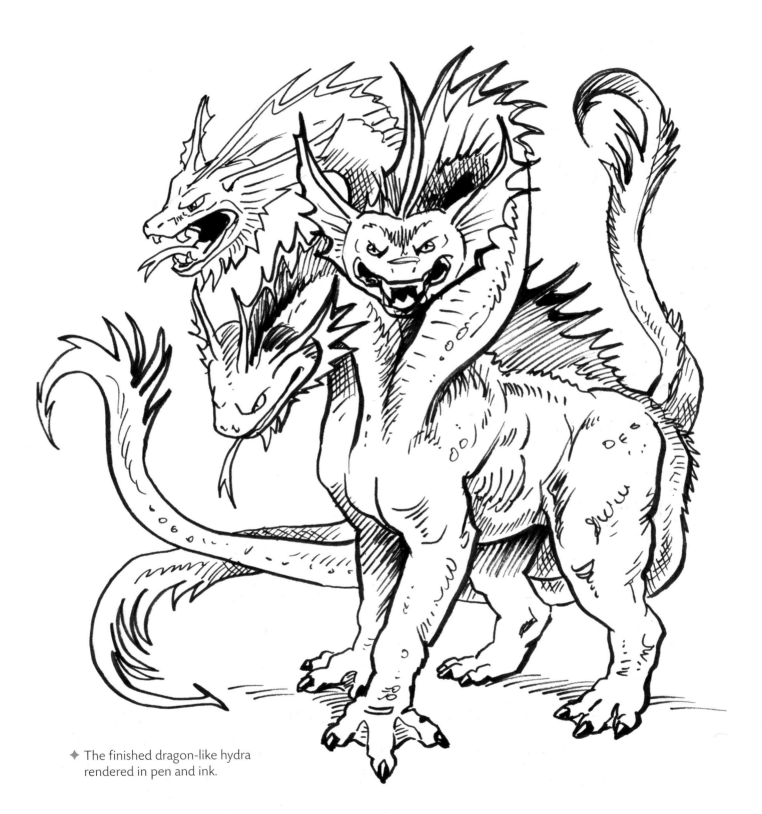

✦ The finished dragon-like hydra
rendered in pen and ink.

3
Creatures of the Land

This chapter will take a look at mythological creatures that are most commonly found on land. Later chapters will deal with creatures that take to the air, water, or are found in the realm of spirit.

Cockatrice and Basilisk

The cockatrice and basilisk are sometimes confused with each other and have sometimes been used interchangeably. But over time, distinctions have grown. The basilisk is now seen as a serpent-like creature with a crown-shaped crest. In medieval times a few were depicted with eight legs, but others have two legs or none at all. The cockatrice is generally depicted as chicken-like, with the head and body of a rooster; scaly, dragon-like wings; and the tail of a snake. Cockatrices are usually on the small side, while basilisks can range from nearly palm-sized to gigantic. The two creatures are similar in some respects: they can both kill by merely looking at or breathing on another living thing, be it plant or animal. They share a weakness: both can be killed if they look at their own reflection in a mirror or hear a rooster crow. The weasel is the only living creature immune to their fearsome gaze, making it capable of fighting and killing the beasts.

A cockatrice is hatched from the egg of a rooster that was incubated by a snake or toad. The basilisk is the opposite: it hatches from the egg of a snake or toad that has been incubated by a rooster. Of course, being male, roosters don't usually lay eggs, so obviously this was a very rare and strange occurrence.

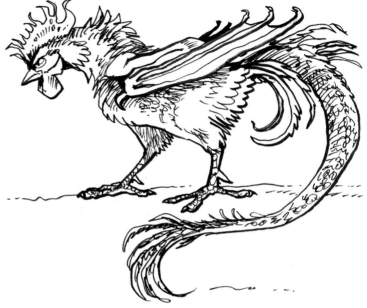

✦ When drawing a cockatrice, you have some leeway, since artist interpretations have always varied. However, remember to get the chicken-like head, scaly wings, and a serpentine tail.

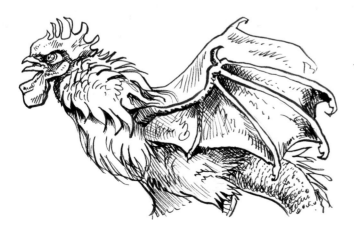

✦ The cockatrice is said to also be able to kill other living beings by merely touching them. In some cases, it reportedly breathes fire. Imagine being chased by a deadly, fire-breathing chicken!

✦ When drawing a rooster, start with the underlying head, beak, and neck , then draw the crest and wattle (the flap of skin hanging over the beak).

76

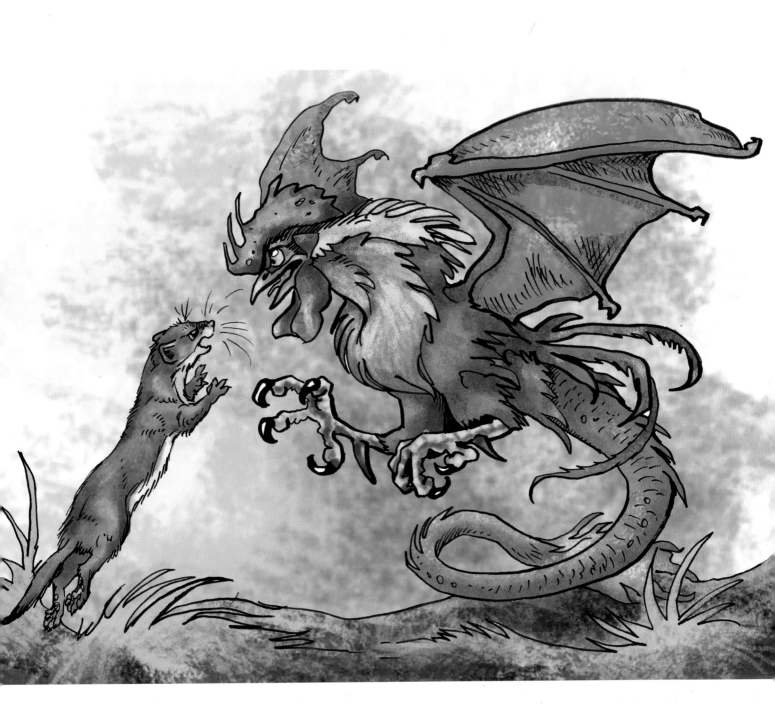

✦ A weasel and cockatrice fight.

✦ Eight-legged basilisk. This one has some iguana-like features. Basilisks vary according to artistic interpretations. Some might be eight-legged, more lizard-like creatures, while others are more snake-like. They have putrid breath that can make one ill, or even kill a person.

✦ Here I drew a cobra-like basilisk while still trying to keep some qualities reminiscent of a rooster along the head by giving it a frill of fins that suggest a rooster's wattle and comb. Even with a serpent's body, the basilisk is said to move forward in a rather un-snake-like fashion. Instead of slithering in waves, the creature's body moves straight forward with the front half entirely off the ground. This might be influenced by the real-life cobra, which raises its head high off the ground and spreads a crown-like hood. It also would explain why a weasel might be the basilisk's mortal enemy, for the weasel-like mongoose is famed as a cobra killer.

Chimera

Greek mythology tells of the chimera, a female monster with the head of a maned lioness with a goat's head on her back and a snake's head on the tip of her tail. This fire breather wreaked havoc and destruction in the lands of Lycia. The hero Bellerophon rode Pegasus (see pages 101 and 111–113) into battle against the chimera and finally killed her with a spear. Today "chimera" can mean any fantastical creature that is composed of various animal parts put together in one form.

✦ Chimera.

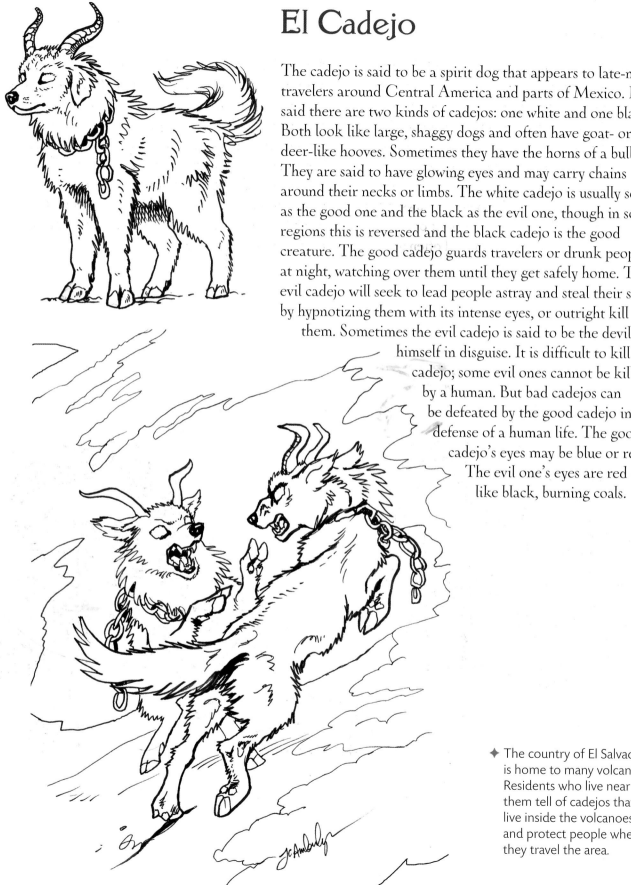

El Cadejo

The cadejo is said to be a spirit dog that appears to late-night travelers around Central America and parts of Mexico. It is said there are two kinds of cadejos: one white and one black. Both look like large, shaggy dogs and often have goat- or deer-like hooves. Sometimes they have the horns of a bull. They are said to have glowing eyes and may carry chains around their necks or limbs. The white cadejo is usually seen as the good one and the black as the evil one, though in some regions this is reversed and the black cadejo is the good creature. The good cadejo guards travelers or drunk people at night, watching over them until they get safely home. The evil cadejo will seek to lead people astray and steal their souls by hypnotizing them with its intense eyes, or outright kill them. Sometimes the evil cadejo is said to be the devil himself in disguise. It is difficult to kill a cadejo; some evil ones cannot be killed by a human. But bad cadejos can be defeated by the good cadejo in defense of a human life. The good cadejo's eyes may be blue or red. The evil one's eyes are red or like black, burning coals.

✦ The country of El Salvador is home to many volcanoes. Residents who live near them tell of cadejos that live inside the volcanoes and protect people when they travel the area.

80

Fu Dog

The fu dog—or shishi (stone lion) in China and koma inu in Japan—is basically a guardian lion that protects shrines, homes, and other important places. This creature's mythological legend is believed to have originated in India and then moved through other parts of Asia, where it sometimes picked up more dog-like traits. Fu dogs have broad heads with powerful jaws, a curly or wavy mane, ears that may be erect or floppy, a compact and muscular build, and often are depicted wearing a jewel. Sometimes they have a horn on their heads. They are usually found in pairs as statues, representing male and female. The male fu dog places his paw on a globe or ball, while the female places her paw gently on a cub. The male has an open mouth, representing the sound "ah," and the female is shown with her mouth closed, representing the sound "mmmm." Together, this produces the sacred sound "om," said to represent the universe in Hinduism.

✦ Fu dog cubs

STEP-BY-STEP FU DOG

1 First, draw a circle for the head and divide it into four equal parts with horizontal and vertical lines crossing in the center. For the chest, draw a similarly sized circle below and slightly to the right of the head. Draw a vertical oval for the hindquarters below and to the right of the chest. Connect the three rounded shapes with a looping spiral, extending a long arch from the head circle (this will form the mane later) around the chest and down and around the hindquarters.

2 Add a muzzle on the bottom left section of the head circle, keeping it deep and short. Draw an eye just above the horizontal dividing line, and then add a furrowed brow line at an angle, as shown. Using the chest circle as a starting point, add the fronts of the front legs, making the backmost leg curve forward. Add ovals for paws on all visible legs.

3 Add the triangular ear, using the slanted brow line for the top and curving the line down from there along right side of the head circle. Draw the nose on top of the muzzle above the horizontal dividing line. Block in the neck and finish the legs. Draw the closer front leg's elbow at the chest circle and then upwards to define the rest of the leg. Draw curved lines on the feet to indicate toes, and draw the tail sweeping up along the back.

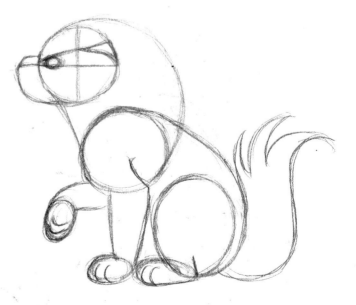

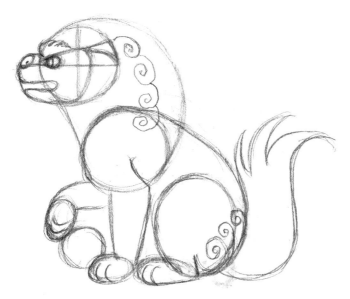

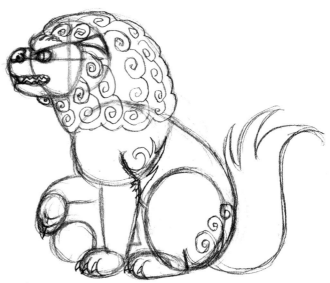

4 Draw a circle for the nose and a dot for the nostril. Place a bushy brow above the eye, sticking out from the head circle a tiny bit. Add an open mouth that extends back to line up more or less with the back of the eye, and define the face by drawing a curving line from the front corner of the ear to the jaw. Begin some of the spirals found in the mane, keeping them fairly evenly spaced and sized. Start in the middle of the mane behind the ear and add a few spirals to the rump. Put a ball under the raised paw.

5 Complete the spiraling curls on the mane, drawing one spiral, then another on the outer end of it, and so on in a line. Then start a new line of spirals next to that. Draw a spiral curl under the chin. Starting at the brow line, define the outline of the mane, adding a poof above the brow, and then sweeping back. Echo the spirals and let them guide you on how your mane outline should flow. Draw sharp teeth and add a smaller circle on the bottom part of the nose for the bulging nostrils. Define the belly and hint at the backmost hind leg. Finally, add claws to the toes and a swirling tuft of hair from the elbow.

6 Ink in or otherwise finalize the drawing and erase unneeded lines after the ink dries.

1 You can have fun drawing cute cubs, too. First block in the head and chest, and make a swirling spiral to indicate the back and hind leg. Keep the head large in comparison and draw curved horizontal and vertical lines to divide it into quarters, curving the vertical line toward the left. (The face is slightly turned to the left, and this line will be the center of the face.)

2 Add the nose where the horizontal and vertical lines meet, or slightly below, and add round eyes on either side. Draw dotted lines that curve up from the inside of the eyes to the top of the head. Draw floppy triangle ears on the outside, at about 10 and 2 o'clock. Use the chest circle to sweep a line on either side down in an arc to form front legs that are slightly bowed in. Add round feet.

3 Add the mouth, making it as wide as the outside of the eyes. (I curved the line up from the corner of the mouth to meet the eyes.) Add a horn with a curved base to give a three-dimensional feel. Complete the front legs and add hind paws (and a little bit of the backmost hind leg under the chest). Draw a collar.

4 Draw a circular shape around the head for the mane, around the head and horn but not under the chin. Add a tongue sticking out of the mouth and evenly spaced, curved lines for the toes. Draw a flowing tail up along its back.

5 Start adding spirals along the most visible sections of the cub's mane. Once those are mostly filled in, fill with squiggly or rounded lines that leave the impression of more curls. You can shade the eyes in, leaving a white highlight, and add small circles on either side of the nose for nostrils. Add a ball to the collar and some curly hair along the cub's elbow.

6 Finalize the drawing by inking the final lines and erasing unneeded pencil ones when the ink dries.

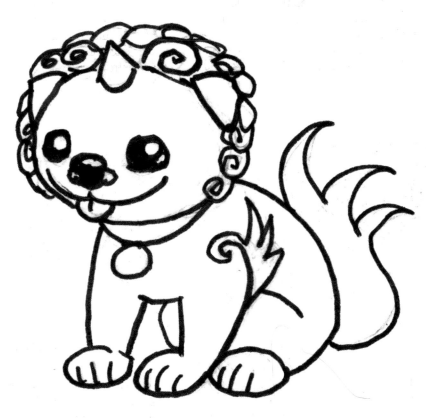

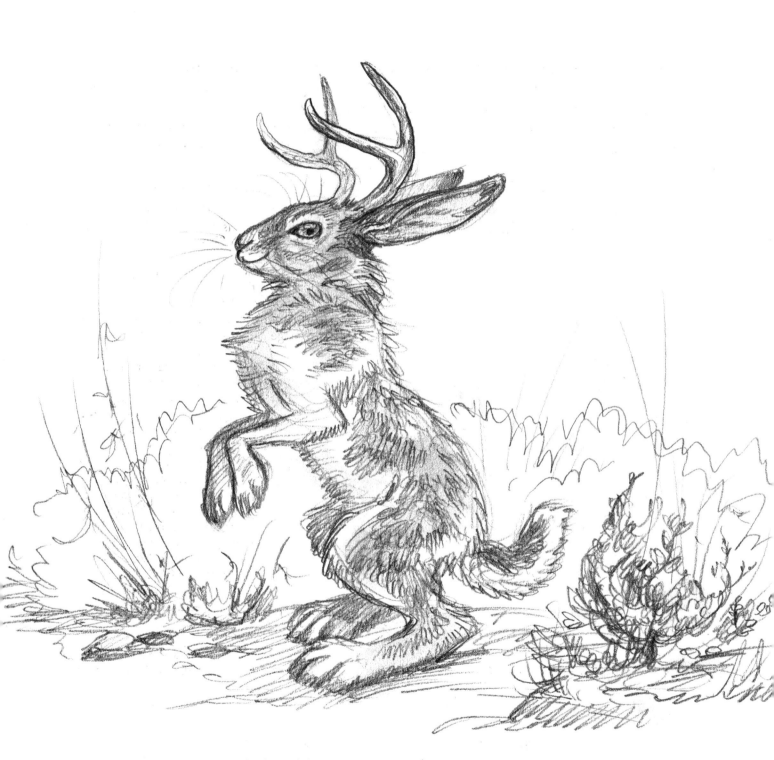

✦ This jackalope is at the jackrabbit end of the spectrum,
not at the antelope end.

Jackalope

The jackalope (a blend of jackrabbit and antelope) is a fabled creature of the western parts of North America, with origins in the state of Wyoming. The antelope in question is the pronghorn, which is not a true antelope but is in fact the only surviving member of the family Antilocapridae, which are more closely related to giraffes and okapi than true antelopes. Meanwhile, the jackrabbit is not actually a rabbit but is the closely related hare. To add to the confusion, the jackalope, despite its name, is most often depicted with deer antlers, not pronghorn antelope horns!

Besides the numerous mounted taxidermy heads of "jackalope" commonly spotted in towns across western North America, there is another possible origin of the creature. Rabbits sometimes get a papilloma virus that causes horn-like growths around their heads and bodies. This could have influenced stories of "horned" rabbits.

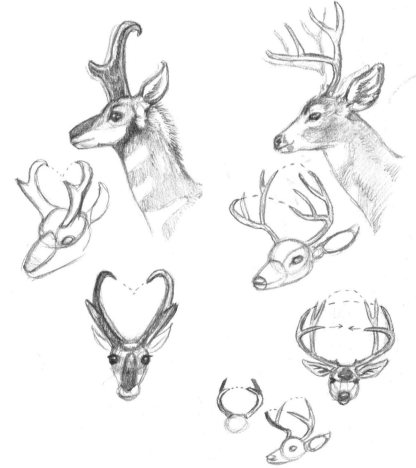

✦ The jackalope is most often depicted wearing the horns or antlers of either a pronghorn (left) or a mule deer (right). These real-life animals roam the western range that's said to be inhabited by the jackalope. The pronghorn has pronged horns that point backwards, and it sheds the outer sheath of the horn each year, leaving a shorter base underneath. The mule deer has antlers that sweep forward, which it sheds completely every winter and grows anew in the spring.

Note how, especially in the front view, the pronghorn's antlers form almost a heart shape. (See dotted lines from horn tips on several drawings.) Also note how circular the mule deer's antlers are. Each tip curls towards the other side (see dotted lines in some of the drawings). Not all deer antlers look exactly this way, but this is a good starting guide. The bottom two sketches show a young forkhorn (two-point buck). Jackalopes are most commonly depicted with a forkhorn mule deer's two-point antlers. The three drawings on top depict a more mature four-point buck.

✦ Here I've made a few sketches showing how pronghorn horns or a forkhorn antler might appear on a jackalope's head.

STEP-BY-STEP JACKALOPE

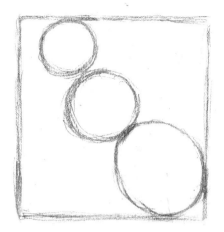

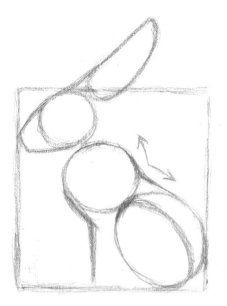

1 It helps to draw a square to guide you. Diagonally inside the square, draw a circle for the head, a slightly larger circle to its bottom right for the chest, and a slightly larger oval to the bottom right of that for the rest of the body. Note how I left some space to the left of the head circle.

2 Draw the blunt-tipped muzzle as shown, sweeping a line down and around from the top of the head. Next sweep a line up and to the right from the muzzle, and then loop it under in a knife-blade shape to block in the long ears. For the closer hind leg, draw a narrower oval inside the bottom body oval. Draw the front leg down from the front of the chest, first angling towards the hind leg, then straight down from the elbow. Connect the chest circle and hindquarter oval by drawing the line for the back (the arrows show the indented shape of the back).

3 Draw a diagonal line separating the top half of the head from the bottom half, then draw the eye along the top half just inside the head circle. Connect the neck and throat and finish the front leg (except the paw). Draw a tail curving up from the rump.

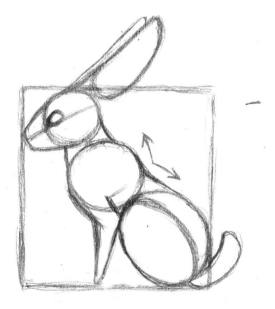

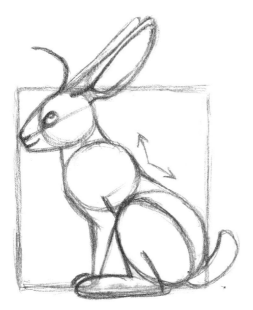

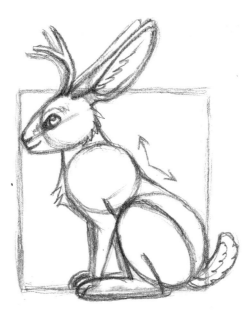

4 Add a small highlight to the eye, then sketch the nose (where the dividing line is) and the mouth below it. Draw lines inside the existing outline to indicate the rims of the ear and add the suggestion of another ear behind the first. Define the hind leg, drawing a line down from the "knee" to where the hind foot is. Then draw the hind foot. Draw the bottom of the foot and sweep that line back up to show the fold of the leg. Now begin to draw the antler as a curved line coming up from the forehead behind the eye.

5 Draw the rest of the antler, in this case a two-point forkhorn, and add another antler just behind it. Finish the details by adding a large pupil to the eye, some squiggly lines inside the ear to indicate hair, a cheek ruff, and the suggestion of a lighter-colored patch above the eye. Draw some tufts of fur sticking out from the chest and add fluff to the tail, defining a section of light-colored hair on the bottom. Add lines showing the legs on the opposite side of the body just behind the closer limbs.

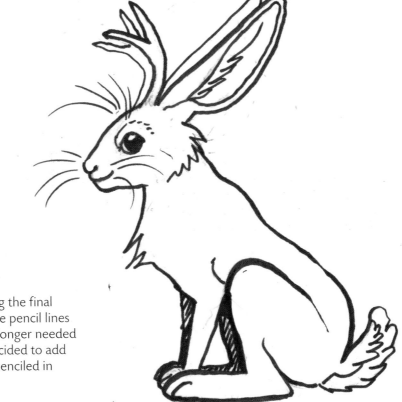

6 Finish the drawing, inking the final lines and then erasing the pencil lines underneath that are no longer needed when the ink dries. (I decided to add a few whiskers, which I penciled in before inking.)

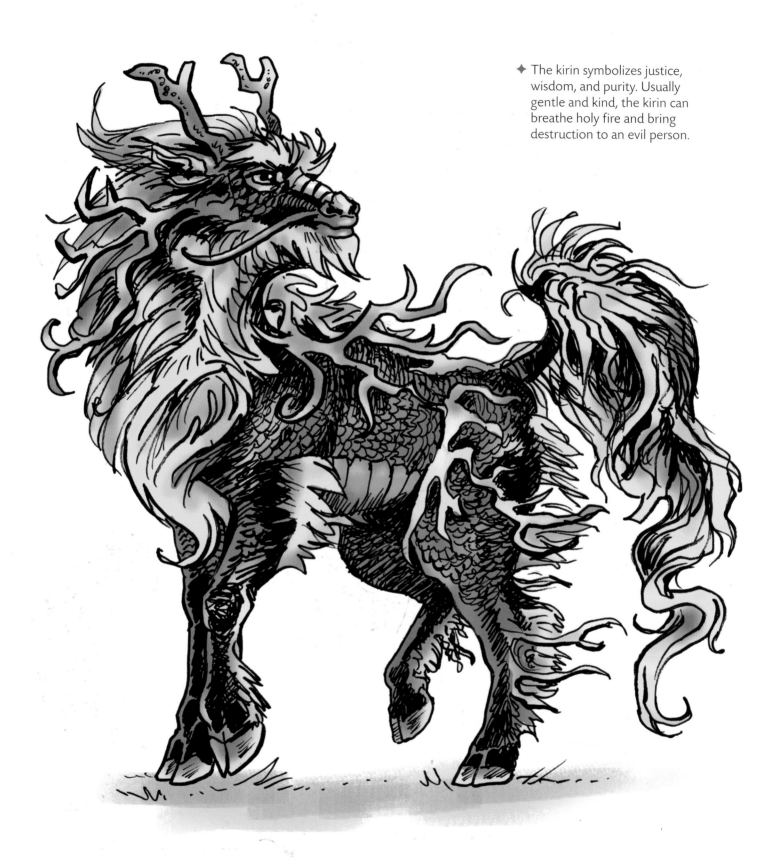

The kirin symbolizes justice, wisdom, and purity. Usually gentle and kind, the kirin can breathe holy fire and bring destruction to an evil person.

Kirin (Qilin)

The kirin is an extremely powerful, rare, and wise creature who is said to be an excellent judge of character that only appears in lands or homes governed by a just and wise person; during times of peace; or at the birth or death of a great ruler or sage. Kirins can walk without harming any living creature, even careful not to trample a blade of grass.

Kirins are chimeras with the body of an ox, deer, or horse and scales and features much like a dragon's. They have cloven hooves and antlers or horns (usually two but sometimes one, which causes some to call them unicorns). The kirin has a beard and thick mane as well as a flowing tail like that of an ox or horse. Its body may have sacred fire (often where the legs meet the body, or along the head and neck) and may be decorated with tufts of hair on the legs. Japanese kirins are often depicted as more deer-like than in China and other East Asian cultures. Kirins may be any color, often tending towards earth tones or jewel colors.

✦ Sketch of a kirin, showing how I blocked in the form.

✦ The finished drawing.

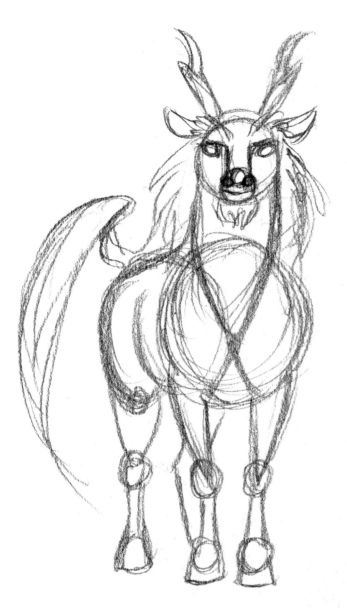

✦ Here's another sketch
 showing how I block
 in the form.

✦ Two possible body types for the basic build of
 a kirin's body. The one on the left has a thicker,
 more powerful neck and bigger chest, while the
 one on the right has a more balanced chest and
 hips and looks more graceful.

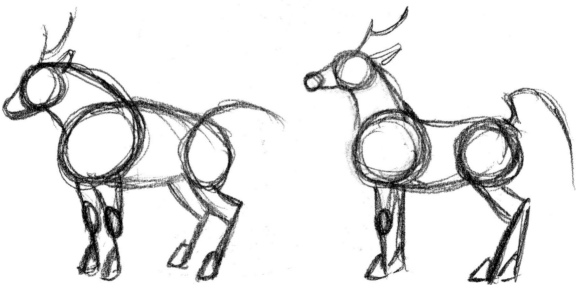

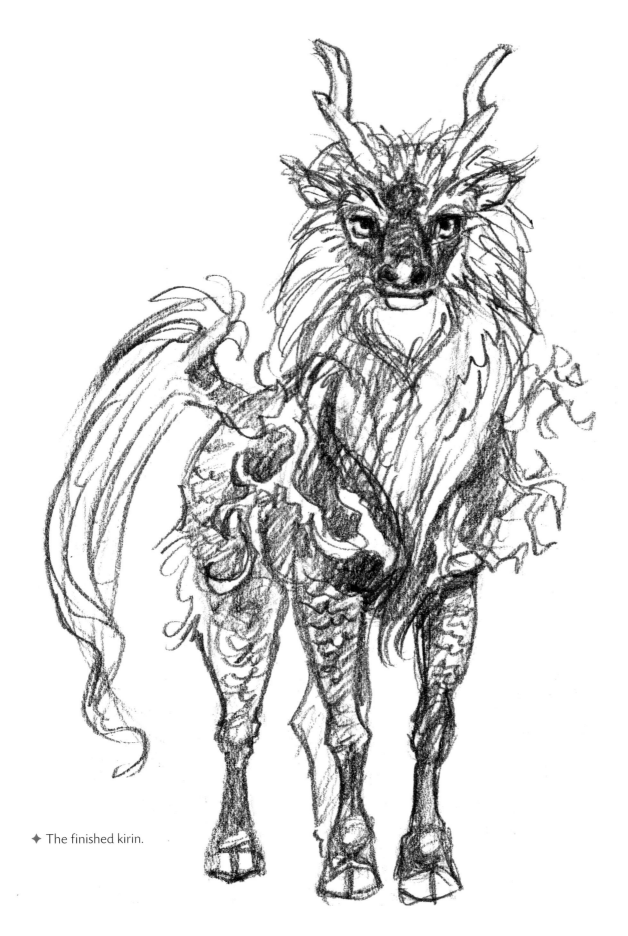

✦ The finished kirin.

STEP-BY-STEP KIRIN

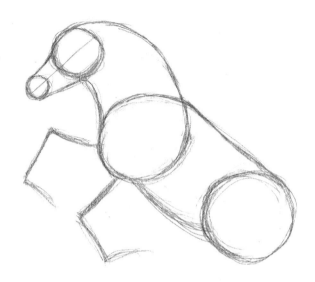

1 To draw a kirin rearing up on its hind legs, begin by drawing a circle for the head, followed by two larger, equally sized circles for the chest and hips. Connect these with an arc for the back of the neck and then loop around the chest to continue a straighter line for the back until you connect to the hip circle.

2 Add a muzzle to the head circle, including a circle at the tip for the mouth and nose area. Draw a diagonal line from nose tip to the back of the head circle that divides the head in half horizontally. Connect the chest and hips, drawing a belly and throat. Begin drawing the front legs, first by indicating the front of the legs in a line that turns at a roughly 90-degree angle, goes straight for a short distance, then angles again.

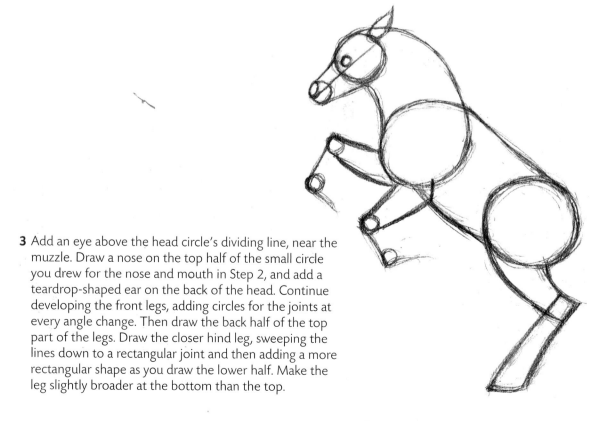

3 Add an eye above the head circle's dividing line, near the muzzle. Draw a nose on the top half of the small circle you drew for the nose and mouth in Step 2, and add a teardrop-shaped ear on the back of the head. Continue developing the front legs, adding circles for the joints at every angle change. Then draw the back half of the top part of the legs. Draw the closer hind leg, sweeping the lines down to a rectangular joint and then adding a more rectangular shape as you draw the lower half. Make the leg slightly broader at the bottom than the top.

4 Draw a bushy eyebrow above the eye, and draw the mouth. Add a branched horn and draw a mane of hair flowing down the back of the neck. Draw a line above and parallel to the outline of the belly, then draw evenly spaced perpendicular lines to indicate large belly scales. Continue working on the front legs, adding most of the rest of the legs and the hooves. Draw a hoof and a circle for the joint above it on the hind leg, then begin drawing the backmost hind leg, largely mimicking the closer hind leg, drawing it down to the same joint above the hoof. Add a flowing tail, emanating from a narrow base.

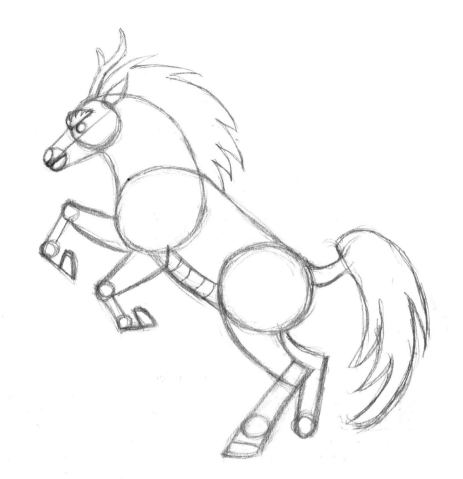

5 Fine-tune the facial details, adding a beard along the lower jaw, a pupil in the eye, a few tufts of hair on the ears, and a nostril on the nose. Draw a cheek ruff. Add more of the mane along the throat and begin drawing the wispy, swirling flames coming up along the kirin's shoulders and hips. Complete the front and hind legs. (The closer hind hoof seemed rather large, so I reduced it slightly in size.) Define more of the hind foot and joints, slimming the leg where needed. Finish the backmost hind leg, adding the hoof sloping forward and down from the joint. Draw tufts of hair on the elbows and front legs.

6 Draw scales on the top of the kirin's muzzle and add an extra horn if you wish. Draw flames along the kirin's neck and add bunches of hair there if needed. Add the dragon-like whiskers extending from behind the nostrils. Draw extra tufts of hair on the tail as desired and indicate scales on the body with rows of wavy lines.

7 Finish the kirin, firming up the lines you want and erasing those you no longer need.

Kitsune

The Japanese word for a fox is kitsune. However, the name does not just refer to the real animal but also a Japanese mythological creature, a yokai (supernatural spirit or monster). The kitsune can start out as a normal fox but through wisdom and experience may gain shape-shifting abilities and grow multiple tails. The wiser and more powerful a kitsune is, the more tails it has (with a maximum of nine tails, which indicates a kitsune that may have lived 1,000 years). At a certain point of age, often 100 years, the kitsune can grow its first additional tail and may gain magical powers such as shape-shifting, illusions, or possessing a person.

✦ Kitsune may be benevolent or harmful. The yako kitsune, or nogitsune, is a wild field fox that may be mischievous or wicked, though it honors promises made and return favors. Higher-level kitsune who have earned nine tails turn a golden or white color, and are known as tenko kitsunes. Kitsune are associated with Inari, the Shinto deity of rice, and are often depicted as guardians and messengers of Inari shrines, known as myōbu (a name also given to a rank of women in the Imperial court). These guardians usually wear a red bib and may carry a jewel or ball on their tail tip, neck, or under their paws. It is said their favorite food is fried tofu, or aburaage.

These creatures are also known for producing a ghostly foxfire, which may appear at night.

Kitsune are known to take the form of a human, often a beautiful young woman, placing a leaf, reeds, or a skull over the head to do so. They may do this mischievously or to be with someone that they love. But their fox-shaped shadow or a tail popping up can give them away in a careless moment! Dogs often react with hostility to a hidden kitsune.

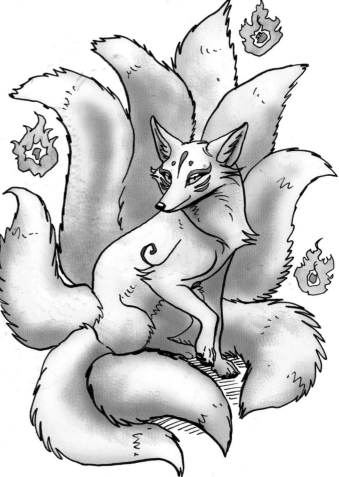

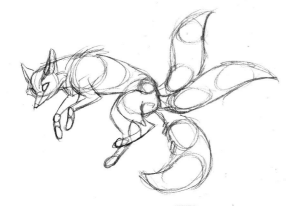

✦ When drawing a fox's tail, keep in mind it is a furry tubular shape that starts narrow at the rump, thickens for most of the length, then tapers to a tip. It can also help to draw an oval as a base when you're sketching out a tail. On the bottom sketch I drew some arrows to depict the basic curves and indents of a typical, bushy fox's tail.

STEP-BY-STEP KITSUNE

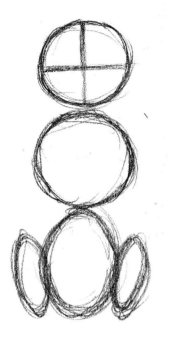 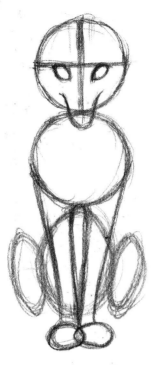 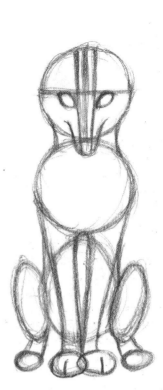

1 Begin by drawing a circle for the head, another similarly sized circle under it for the chest, and then a vertical oval underneath that for the hips. For the hind legs, add two smaller ovals, slightly angled out, on either side of the vertical oval, aligning all at the bottom. Divide the head circle evenly into quarters with vertical and horizontal lines that intersect in the center.

2 Add a muzzle by drawing a U shape that widens at the top, placed at the bottom part of the head circle. Draw the somewhat slanted eyes, lining the top edges at the horizontal dividing line. Add the front legs by drawing down from the side of the chest circle and below the hips; draw an oval at the end. There should be a teardrop- or baseball-bat-like shape in the space in between the legs. Draw the other front foot, overlapping a little as shown.

3 Block in some vertical guidelines in the middle of the kitsune's head, lined up with the inside corner of the eyes and going down to the tip of the nose. Connect the head and chest with some lines indicating the neck. Connect the hind legs and hips to the body. Draw a line in the center of the front feet to begin defining toes, and add tubes ending in ovals for the hind feet.

4 Use the Step 3 vertical guidelines to place and draw the ears and nose. The nose is centered between the guides at the tip of the muzzle. Draw the ears at the top of the head from the outside of the vertical guidelines, down to the horizontal guideline. Draw cheek ruffs from the horizontal guideline down to the neck. Draw pupils. Erase the overlap of the front feet, choosing one foot to be slightly in front of the other. Add more toes by drawing lines on either side of the middle lines, creating four toes. Add a line in the center of the hind feet, then add toes the same way. Connect the bottom of the hind legs to the hips.

5 First lighten (slightly erase) the lines on the face so it is easier to add more details, then add a teardrop shape on the forehead and a dot above each eye. Add details to the ears, including a line to show the rim of the inner ear and a few squiggly lines depicting some hair. Add highlights to the eyes and then claws to the front paws, starting with the two in the middle. The claw tips should point slightly towards each other. Draw a ruff of fur on the sides of the chest circle and add a few wavy lines in the middle to depict a tuft of hair there, too. Next add tails, starting with the closer two on the bottom. This will be a five-tailed kitsune.

6 Add some more marks on the kitsune's cheeks and shade the nose, leaving a spot for a highlight (so the nose appears shiny). Add the rest of the claws and the tails.

7 Finish the drawing by darkening the main pencil lines and erasing the unnecessary ones, or by inking the main lines and erasing the pencil when the ink dries.

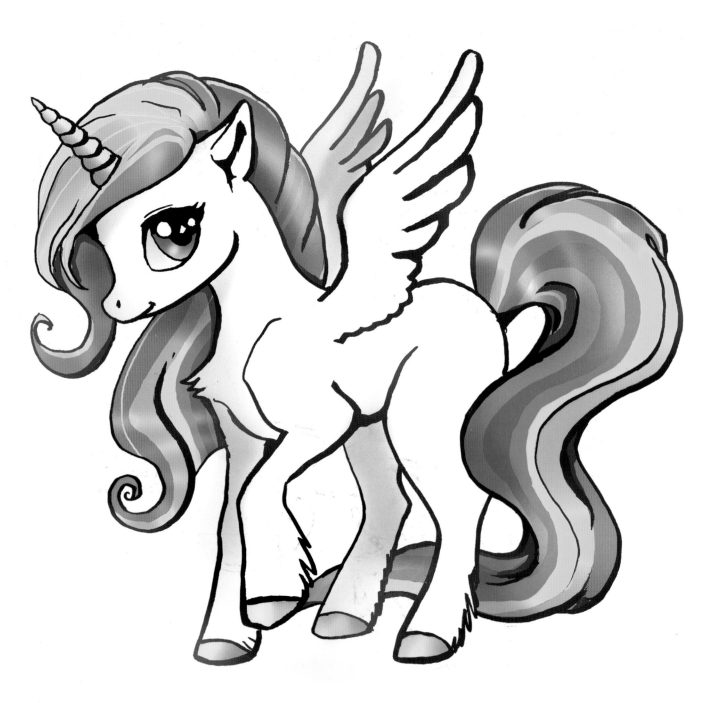

✦ A cute alicorn.

Unicorn and Pegasus

As we discussed in chapter one, there is no one right way to draw a unicorn, Pegasus, or similar creature, but generally, horse-like features are a good starting point. The several drawing demonstrations here include realistic as well as a cartoon-like approaches.

UNICORNS

Unicorns have captivated the human imagination since antiquity. Usually depicted as a horse with a horn, they sometimes have goat- or deer-like features. Unicorns have long been symbols of purity, and evasive of humans, though a virgin woman might tame one. The narwhal, a whale-like mammal with a long, specialized tusk that looks like a classical unicorn horn, and even a one-horned goat, may have been real-life inspirations for the legend.

✦ Like most classic unicorns, this depiction is based on a horse.

PEGASUS

Pegasus is the divine winged horse of ancient Greek legend who sprang from the blood of Medusa when she was slain by Perseus. Poseidon was considered Pegasus's father. Over time in Western culture the Pegasus has come to mean any winged horse. There are tales of winged horses from other cultures as well, including the Chollima from East Asia, said to be so swift no mortal human can ride it, and the brave Tulpar, patron of hunters who used horses and birds of prey to hunt. Tulpar is the centerpiece of the national emblems of Kazakhstan and Mongolia. Lastly, a magical horse that combines both a horn and wings is often called an alicorn.

STEP-BY-STEP UNICORN'S HEAD, THREE-QUARTER VIEW

1 Draw a circle for the main part of the head, then a smaller circle for the muzzle slightly below and to the left of it, then draw lines to connect the two.

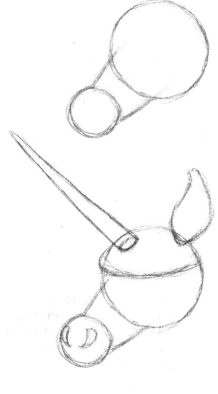

2 Now draw a slightly curved, mostly horizontal line around the center (maybe just a little above center) of the main head circle. It can jut out slightly past the far side of the head (this is the bulge of the eye socket on the far side; go ahead and connect it to the head). Draw teardrop-shaped nostrils on the nose, keeping the one that appears closer a bit larger than the other. The other (back) nostril subtly curves around the nose and can be drawn closer to the outer edge of the muzzle circle. Draw a teardrop-shaped ear towards the right side of the head and place a horn on the top left with a slightly curved bottom. You can draw an oval shape where it connects to the head if this helps you visualize it.

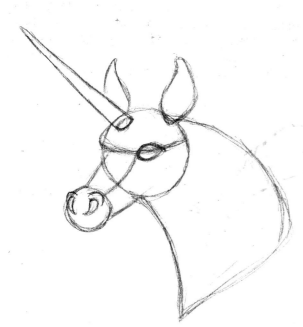

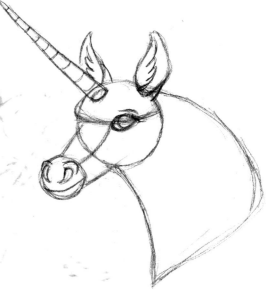

3 Draw the almond-shaped eye along the horizontal line of the head circle. You can add another, slightly curved guideline extending from the tear duct of the eye down towards the nose, ending above the closer nostril. Add small lines indicating the top fleshy part of each nostril above the teardrop-shaped holes. Draw the backmost ear, the tips of both ears curving towards each other. Next draw the neck.

4 Add the pupil to the eye and draw a line above the eye to indicate an eyelid. Draw some squiggly, shaggy lines inside the ears to indicate tufts of hair, then add an outside base connecting each ear to the head. Use a slightly curved line to indicate the mouth inside the muzzle circle. Draw ridges on the horn.

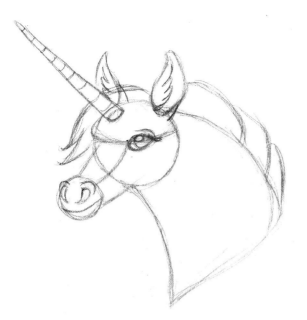

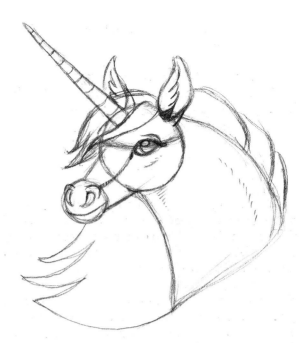

5 Draw a highlight in the eye and add some eyelashes. Draw the bangs and mane, starting with the outline above the head and neck first. You can draw the mane in sections like waves overlapping each other as they flip over the neck and start flowing down the other side.

6 Finish blocking in the drawing by adding the rest of the mane. (I made the bottom of the mane connect to the line I drew earlier showing the end of the neck.) You can experiment with the mane's length or curl. Add the rest of the bangs over the forehead, drawing a long strand of hair sweeping along the base of the horn and down the muzzle. If you wish, add sketchy shading under the eyeball, and along the neck where tendons and muscles may be noticeable, like along the throat.

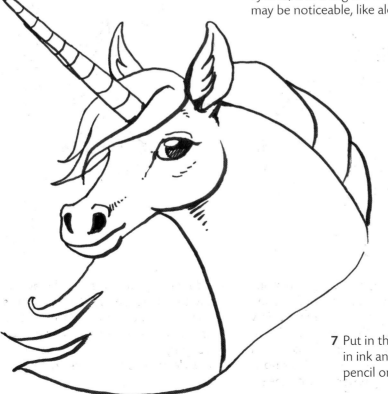

7 Put in the final lines in ink and erase unnecessary pencil ones when the ink dries.

STEP-BY-STEP CUTE CARTOON UNICORN

1 Draw a circle for the head (it will be large in comparison to the body). Then draw a line slanting down from it for the back of the neck, a more-or-less horizontal line (with a slight upward tilt) for the back, and then another circle under it for the hindquarters. There should be about one circle's space between the two circles.

2 Between the circles, draw a smaller circle (almost oval) for the chest, joining the back line on top and extending down so the bottom is about level with the bottom of the hip circle. Leave space between the chest circle and neck as well as between the chest oval and hips. Draw crossing horizontal and vertical guidelines on the head circle, slanting down towards the left somewhat, as shown.

3 Add the muzzle to the head, using the head's (slightly slanted) horizontal line as the starting point for its top. Sweep the line to the left, letting it swoop a little bit down before turning up in a very subtle manner at the tip. Sweep down and back towards the jawline, steeply at first and then very gently as this line meets the arc of the head circle. Add the front leg under the chest, drawing a subtly forward-curved line. Then make an almost flat bottom for the hoof, and sweep back up again to the body. Connect the head, chest, and hips. Begin the hindquarters from the hips, sweeping to a point below and slightly behind the right part of the hip circle.

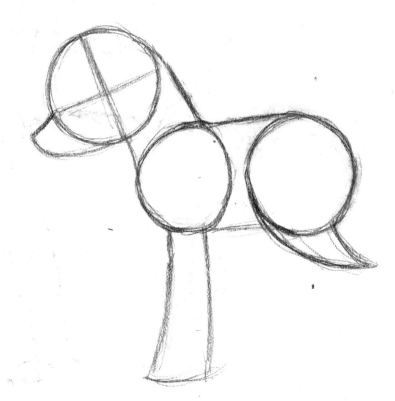

4 Draw a large eye just to the left of the (slightly slanted) head's vertical line and center it on the horizontal line. Add a small nostril on the muzzle and a triangular ear to the top of the head circle just right of the vertical line. Draw the rest of the hind leg, making sure the bottom of the hind foot is about level with the bottom of the front foot. For the front of the hind leg, draw a line from the rump down that juts out a little to the right from the hip circle. Then add a small circle to the front leg for the joint. Sketch in the backmost front leg under the chest circle, using a smaller and slightly higher circle for its joint. It should lean slightly forward of the closer front leg.

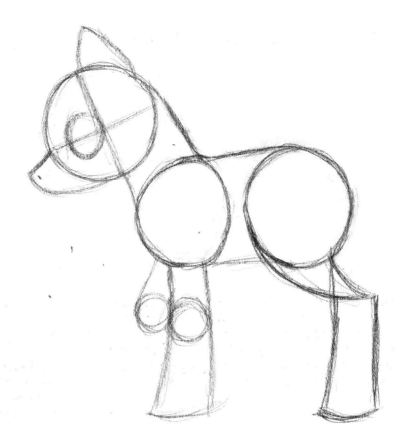

5 Draw a pupil and highlight in the eye and a horn on the head. Draw a mouth and a small line inside the ear dividing the front and back of the ear. Finish the backmost front leg by angling it back, and the backmost hind leg, as show. Add hooves on the closer legs, and a long tail.

6 Draw the mane, including a swirly bang over the forehead and more hanging to the opposite side of the neck. (I used some dotted lines to show you how the mane connects from the back of the neck to the flowing part in front.) Draw a line inside the bangs where the horn will be visible jutting through them. Add the backmost hooves. Draw a pupil inside the iris and a few eyelashes if you like. Add a few tufts of hair on the tail tip using V shapes as shown. Add a tuft of fur on the chest.

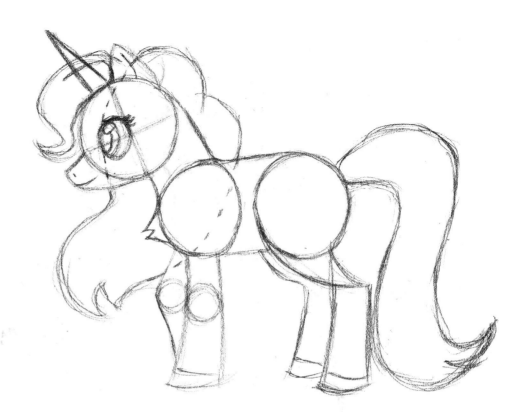

7 Finish the drawing with ink and/or pencil and erase any unneeded lines after the ink dries. (I added a small line along the body where the "elbow" would be, connecting the front leg to the body, and made sure to keep a little of the chest circle visible to indicate the shoulder, too. I also added a slight shagginess to the legs, a few lines in the hair, and lines on the horn.) Feel free to experiment, drawing wings instead of a horn to make it a Pegasus or trying different styles and shapes for the mane and tail.

DRAWING A UNICORN HORN

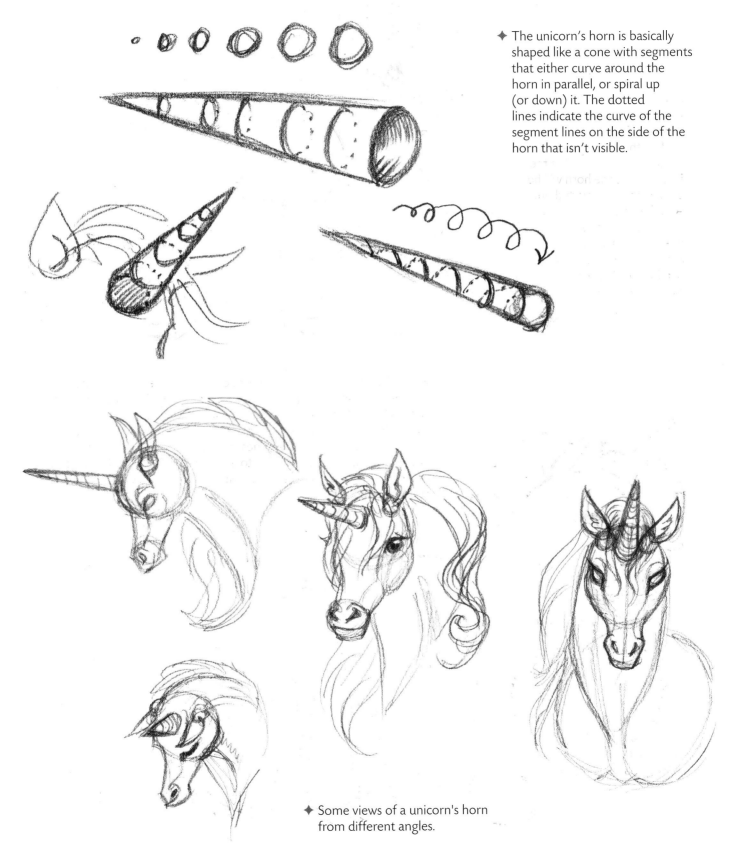

✦ The unicorn's horn is basically shaped like a cone with segments that either curve around the horn in parallel, or spiral up (or down) it. The dotted lines indicate the curve of the segment lines on the side of the horn that isn't visible.

✦ Some views of a unicorn's horn from different angles.

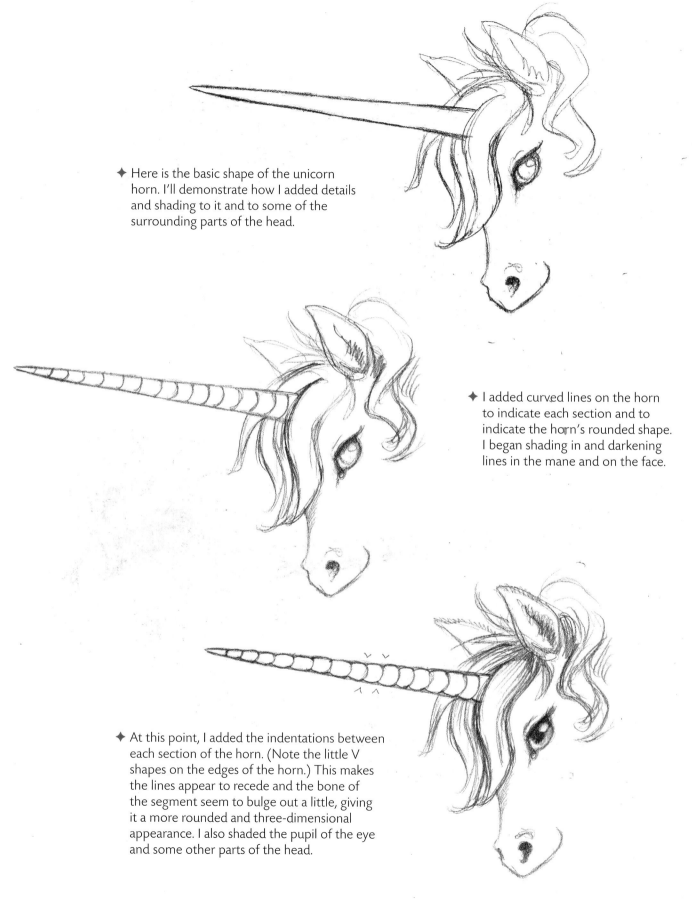

✦ Here is the basic shape of the unicorn horn. I'll demonstrate how I added details and shading to it and to some of the surrounding parts of the head.

✦ I added curved lines on the horn to indicate each section and to indicate the horn's rounded shape. I began shading in and darkening lines in the mane and on the face.

✦ At this point, I added the indentations between each section of the horn. (Note the little V shapes on the edges of the horn.) This makes the lines appear to recede and the bone of the segment seem to bulge out a little, giving it a more rounded and three-dimensional appearance. I also shaded the pupil of the eye and some other parts of the head.

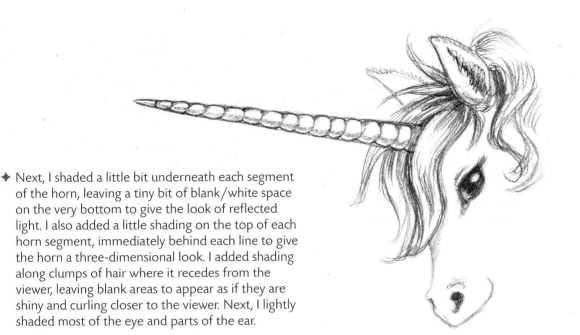

✦ Next, I shaded a little bit underneath each segment of the horn, leaving a tiny bit of blank/white space on the very bottom to give the look of reflected light. I also added a little shading on the top of each horn segment, immediately behind each line to give the horn a three-dimensional look. I added shading along clumps of hair where it recedes from the viewer, leaving blank areas to appear as if they are shiny and curling closer to the viewer. Next, I lightly shaded most of the eye and parts of the ear.

✦ Finishing the horn, I added a little bit more shading along each segment line, as well as a bit of very light shading under the horn where the reflected light hits shadow. I erased lines as needed. I also added more shadow to the base of the horn next to the hair and more shading and hair details along the head. In a lot of cases I used the crosshatching technique of one row of lines crossed with another row angling the opposite way.

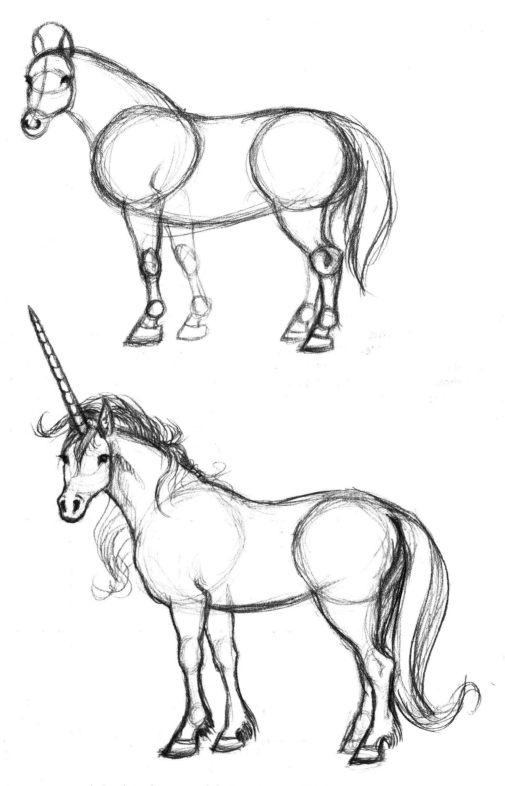

✦ Studying horses and their anatomy will help you considerably whether you are drawing a unicorn, alicorn, or Pegasus. I drew a horse on top and "embellished" it to create a unicorn, below, with a horn, more tufts of hair on its legs, and a longer, fuller mane and tail.

STEP-BY-STEP PEGASUS IN PROFILE

1 Start by lightly drawing a nine-square grid, three squares up, down, and across as shown. This is a guide you'll later erase, so keep it light. Next draw two equal circles at the central lower junctions of the vertical and horizontal lines as shown. This will be the chest and hips of the Pegasus. Keep the circles low, focused in the top half of the lower third of the grid.

2 Draw a curved line extending from the left (chest) circle to depict the curved neck, and loop it around into a smaller circle for the head. That head circle should be slightly above the horizontal line extending through the chest and hips. Draw a cone-like muzzle, letting it extend under that same horizontal line a little bit. Draw a diagonal line through the center of the head from the tip of the muzzle to the back of the head, leaving equal space above and below.

3 Draw the back, connecting the tops of the two equal-sized circles with a slight dip in the middle. Draw the belly and the throat. Add a tail, arcing it so the top of it lines up more or less with the top of the head.

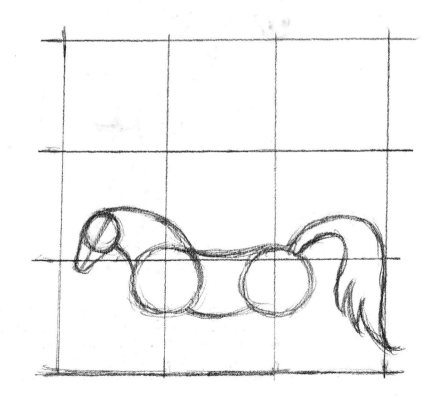

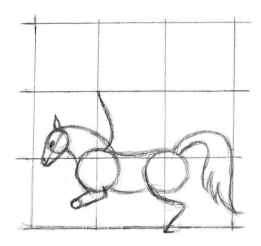

4 Now add features to the head, including an eye placed inside the head circle, above the line bisecting the head. Add the nostril, mouth, and a teardrop shape for the ear where the back of the neck connects to the back of the head. Begin adding the legs, starting with the front leg folded up towards the chest, ending with a circular wrist joint on the end. Draw the front part of the closer hind leg extending down from the hip circle. The hoof should just poke through the horizontal line on the ground. Finally, begin the wing by drawing a line reaching above Pegasus's shoulder and curving up to meet the intersection of the grid above the main body.

5 Put some hair (bangs) on top of the head. Draw more of the front leg (as a small tube), folding it down from the first, big wrist joint and ending with a smaller joint circle where the hoof will be attached. Draw the top part of the backmost front leg, angling it straight down with a circular hoof joint at the bottom. Finish the hind leg down to the hoof joint, which aligns with the bottom horizontal line. Draw more of the wing, adding big primary feathers flaring out from the top part of the wing, much like fingers from a hand. The top two feather tips align with the highest of the horizontal lines and come back to line up with another cross-section of the grid above the hip circle.

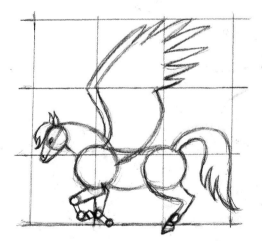

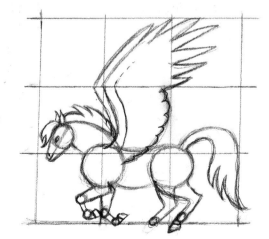

6 Draw the underside of the wing, at this point using a curved line to indicate where the general edge is, connecting it to the back of the chest circle. (You'll go back and fine-tune feather detail later.) Draw the other, backmost wing layered behind the front wing and add the backmost ear. Add the front hoof, which should just touch the vertical line of the grid coming down from the chest circle. Add the long, slender part of the backmost front leg, then finish the hind leg. Be sure to draw hooves once legs are completed.

7 Now go back and add small bumps indicating the silhouette of feathers along the edge of the lower wing. Draw a line to indicate the underlying bone structure of the wing where it raises up from Pegasus's shoulders as shown. Complete the front legs and begin the backmost hind leg extending from the hip circle. Complete the mane on the neck. Finish the legs.

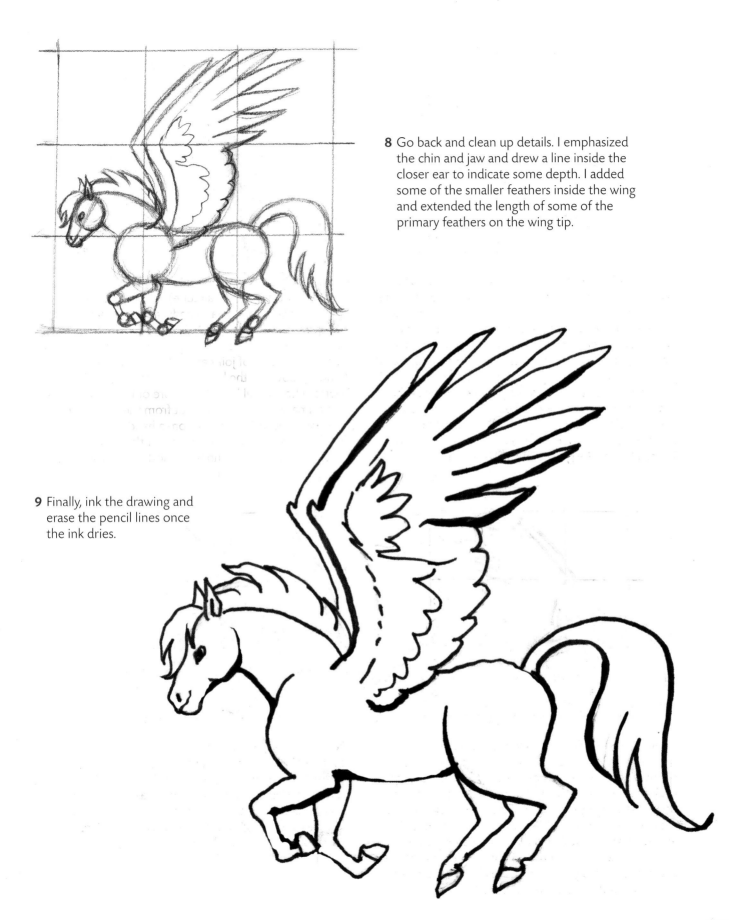

8 Go back and clean up details. I emphasized the chin and jaw and drew a line inside the closer ear to indicate some depth. I added some of the smaller feathers inside the wing and extended the length of some of the primary feathers on the wing tip.

9 Finally, ink the drawing and erase the pencil lines once the ink dries.

4
Creatures of the Air

In this chapter we will look at mythological creatures that soar across the skies. Most do come to land, but all have wings of some sort that allow them to fly.

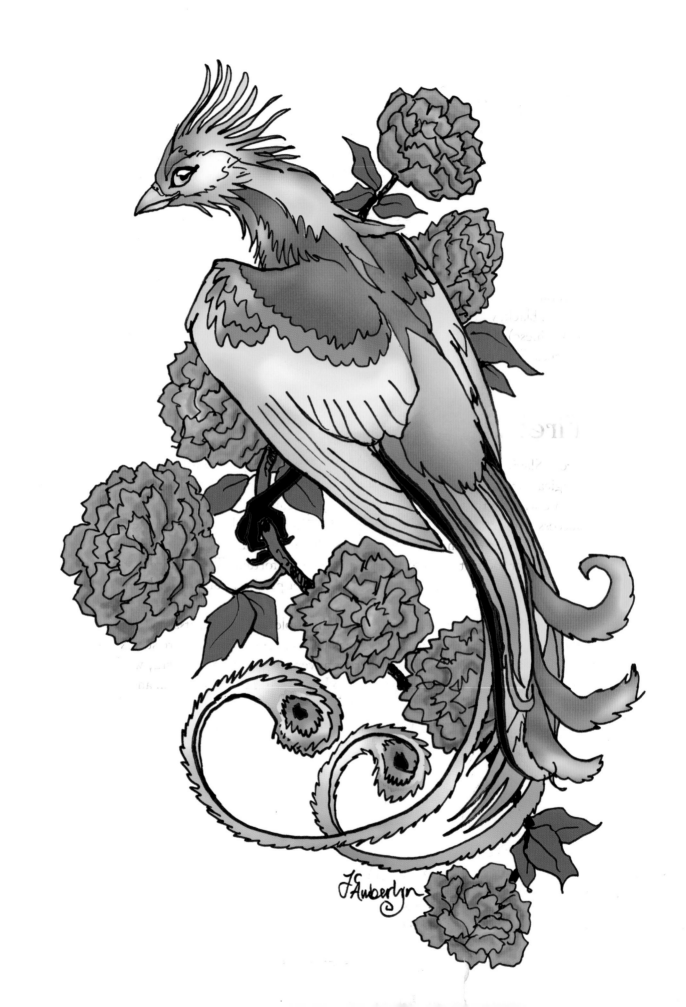

J. Amberlyn

Fenghuang

The fenghuang is sometimes called the Chinese phoenix, though it is not really related to the phoenix. It is a rare, immortal bird that is often paired with the dragon as a representation of marital harmony—the fenghuang represents feminine energies (and is the symbol of the empress), while the dragon represents masculine ones (and is the symbol of the emperor). The word itself is actually a combination of two: male (feng) and female (huang). This legendary bird is often used as a symbol of prosperity and harmony and is said to be a sign of world peace. It can be associated with fire (like several legendary birds) and has what are considered the five fundamental colors: black, white, yellow, red, and green (sometimes blue-green, or qing, in Chinese). These colors are said to represent Confucius's Five Constant Virtues: Benevolence, Justice, Ritual, Knowledge, and Integrity.

Firebird

From Slavic folklore come tales of the firebird, an extraordinarily beautiful, magical bird with glowing feathers that is often the object of many a quest. Those who try to capture the firebird and its beauty may encounter riches and success—or great tragedy. It may bring blessings to a village or to people in need, such as dropping pearls from its beak so that peasants have something to trade for food. It can also bring curses and misfortune. The firebird's feathers glow so intensely that even one feather plucked from the bird can light a dark room.

A tale from Russia tells of a firebird that stole apples from a tsar, who sends his sons to capture the bird. The youngest, Prince Ivan, is more successful than his older siblings and has numerous adventures. After a great gray wolf eats Ivan's horse, the wolf makes it up to Ivan by offering to carry him and giving advice, which Ivan often fails to follow. Eventually, however, the wolf helps him get the firebird, a new horse, and the love of a beautiful woman.

OPPOSITE: A fenghuang perches on peonies. Peonies are native to China and were once the official flower of China, eventually replaced by the plum tree. The peony still symbolizes wealth, nobility, and feminine beauty.

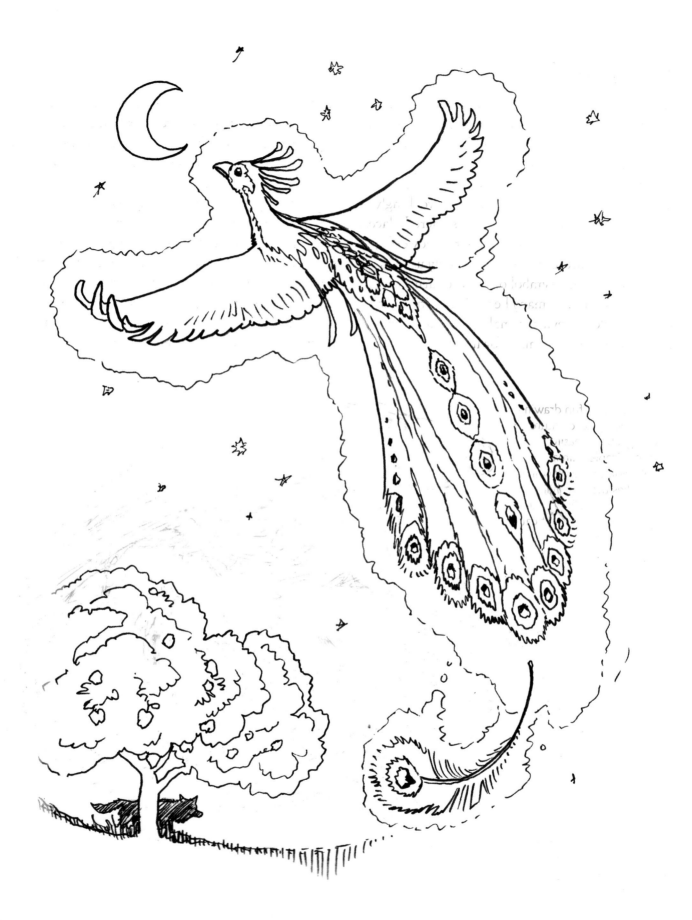

Gryphon

The gryphon (or griffin) has the head, feathered wings, and front legs of an eagle and the hindquarters and tail of a lion. The lion was considered the King of Beasts and the eagle the King of Birds, so their combination is a powerful symbol. The gryphon is considered an aggressive, kingly creature that often guards treasures, sacred places, or royal families. Because of its fierce, powerful, and majestic nature it was and is widely used as a mascot or heraldic symbol on coats of arms, flags, and other things. In many heraldic traditions, it does not tolerate evil and makes a great and just guardian. It is said to mate for life. However, humans and gryphons can sometimes clash, for gryphons have an appetite for horsemeat, and some gryphons may attack humans who get too close to their treasure. It is said on rare occasions, a gryphon and horse actually mate, and the resulting offspring are called hippogriffs (see page 128).

Gryphons are usually shown with tufted ears, though earless and even wingless ones are occasionally seen in ancient depictions. In a few places, it was said only female gryphons have wings, but popular depictions usually give all gryphons wings.

Drawing gryphons is essentially drawing an eagle and a lion and combining the two.

✦ You can have fun drawing a mythological creature doing a basic, easily recognizable animal behavior, such as yawning. It makes the unfamiliar look more familiar. With gryphons, thinking of cat or eagle-like behaviors is especially relevant.

OPPOSITE: This firebird soars above an apple orchard at night, watched by a great grey wolf.

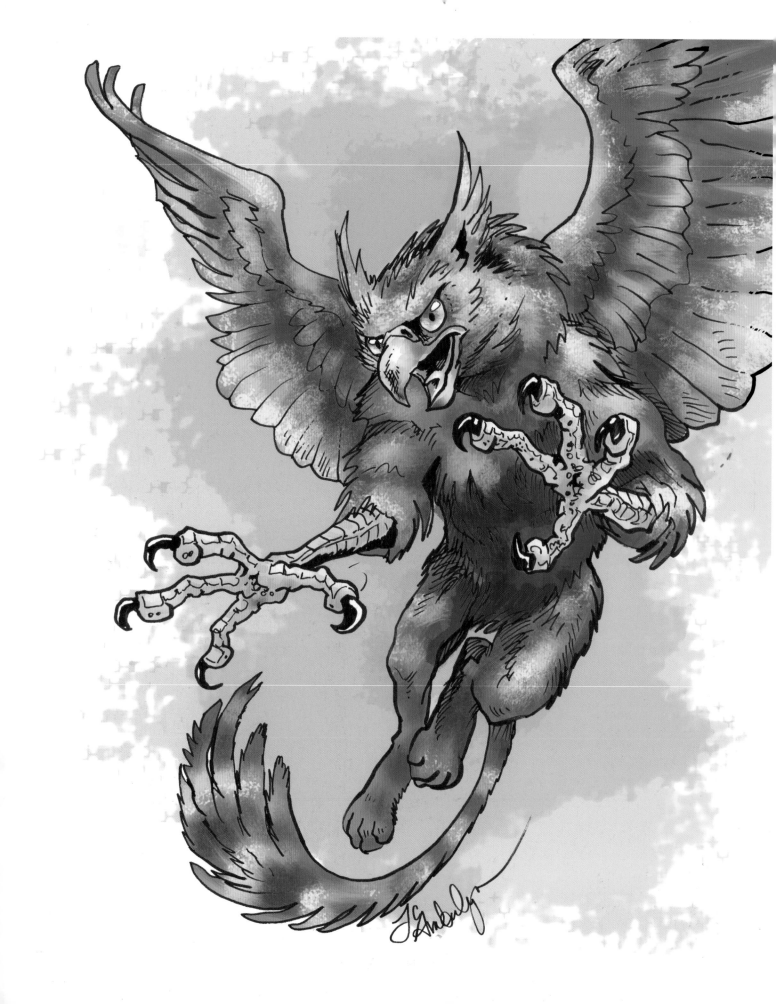

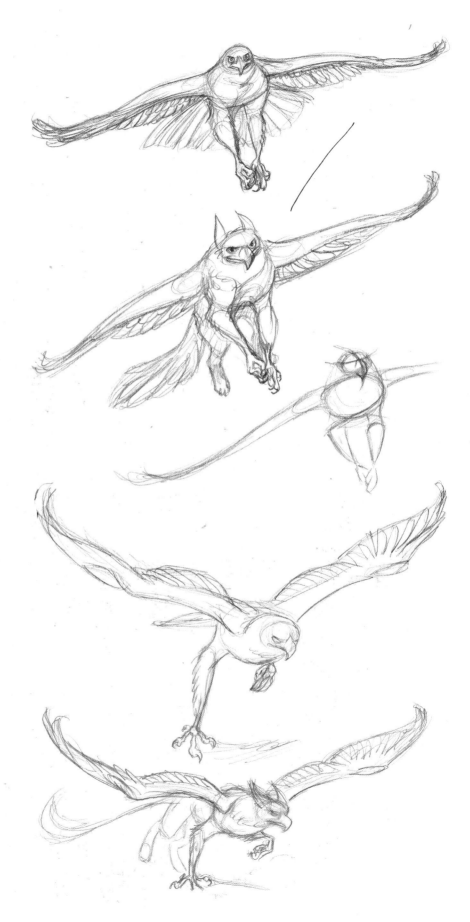

- To draw a gryphon, merge the hind end of a lion with the front of an eagle. Here's an eagle sketch, with emphasis on the positions of the wings and legs. This forms the basis for this gryphon drawing.

- Here's my completed gryphon, with the lion hind merged with the eagle front. I sketched the basic form of the eagle below the finished drawing.

- Below the gryphon is another example of a real-life eagle pose and the gryphon I drew based on it (below).

OPPOSITE: This drawing really highlights the power, strength, and eagle-eyed focus of the gryphon.

✦ In these quick sketches of gryphons (left), I'm going for gesture and blocking in basic anatomy.

✦ In the top right sketch, the curving arrow line emphasizes how the main thrust of action winds up from the tail, along the spine, and out through the tilt of the wing. This is an action line, depicting the main thrust of movement. The sketch below it also blocks in the gryphon with simple lines that explore structure and proportion. Making quick sketches can help you explore the form of the creature and become more familiar with its anatomy and how you interpret it.

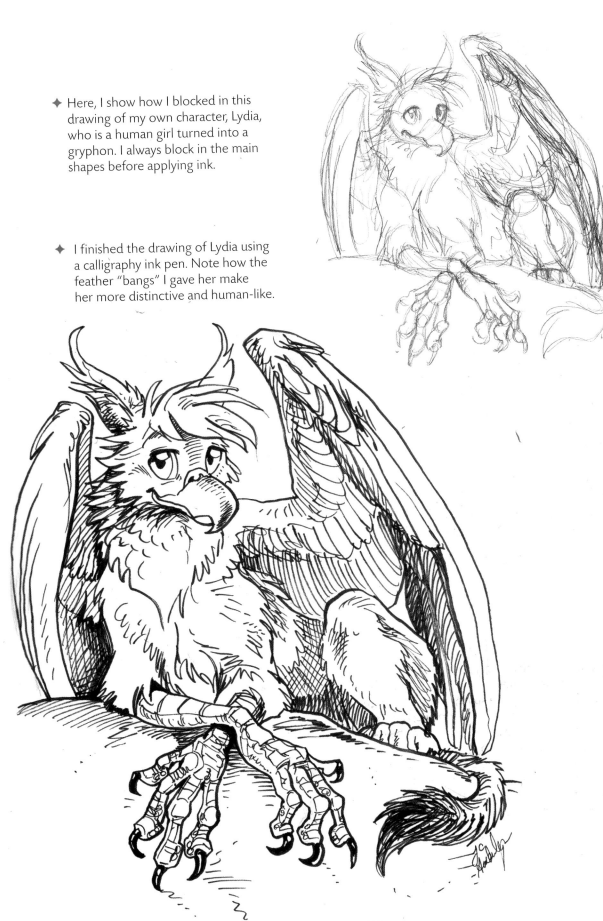

✦ Here, I show how I blocked in this drawing of my own character, Lydia, who is a human girl turned into a gryphon. I always block in the main shapes before applying ink.

✦ I finished the drawing of Lydia using a calligraphy ink pen. Note how the feather "bangs" I gave her make her more distinctive and human-like.

✦ Here, I've drawn some baby gryphons. The key to making an animal look young is to draw the head, eyes, and feet larger in proportion to its body than you would for an adult.

STEP-BY-STEP HERALDIC GRYPHON

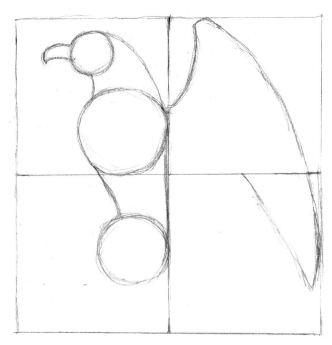

1 Draw a (roughly) square 2 x 2 grid, divided into even quarters. Draw the gryphon inside the grid, starting with a larger circle for the chest, placed in the bottom right corner of the top left square, touching the guidelines. Draw a smaller circle for the head in the top center of the same square, not quite hitting the top line. For the hindquarters, draw a medium-sized circle in the bottom left square, centered at right on the vertical grid line.

2 Now connect the head, chest, and shoulder circles with curved lines for the back, neck, throat, and belly. Draw a curved top beak on the left of the head circle (you'll draw the bottom part next, so leave room for it). Begin the wing, drawing it arching up to the top of the top right square, curving down to hit about halfway into the lower right square before sweeping back up to the horizontal dividing line (creating the tip of the wing).

3 Finish outlining the wing, bringing the lower edge back to connect behind the shoulder. Now begin the legs. Draw the closer top leg by sweeping a curved line from the top of the chest circle, around, then out, and back, so the leg's elbow touches the horizontal guideline. Add an oval to the end for the front foot. Both hindquarters begin curving from the top of the hindquarters circle. Draw the hind leg with the heel's edge close to the vertical guideline, adding an oval for the hind foot that hits the bottom of that square. Draw the backmost front leg kicking out in the air, leaving room at the left side of the section, then add its foot oval. Draw the lower part of the beak, connecting it to the bottom of the head circle. Draw the feathered ear; the tip will hit the top of the square, then sweep back into the head circle.

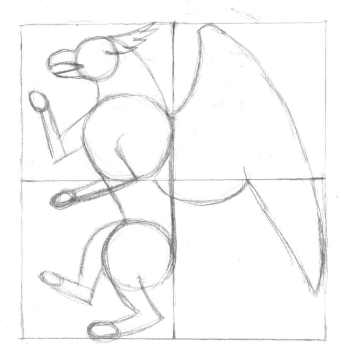

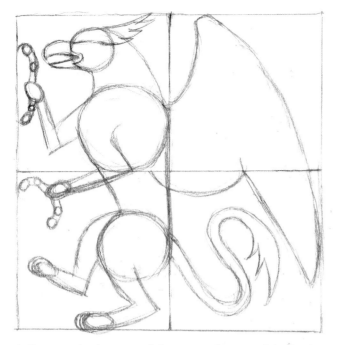

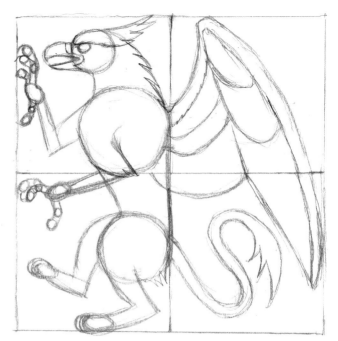

4 Connect the bottom of the ear to the top of the beak with a relatively horizontal line (more or less, though some curvature is to be expected). Define the beak and corners of the mouth. Begin adding toes, drawing tubes for the longest front toe and the back toe, adding little circles for knuckles and then a circle at the tips. Draw the toes on the hind feet, adding more shape and bulk behind the foot's original oval shape. Draw the tail in the bottom right section as a sort of S shape with a tuft on the end.

5 Add the eye under the brow line you just drew between the ear and top of beak. Add the section for the nostrils, or nares, at the base of the top beak. Define the front leg's separation between feathers and scaly leg at the elbow and add some tufts of fur or feather along the neck and rump. Draw the rest of the toes. Add sections for the various blocks of feathers inside the wings. Draw a line just inside the top part of the wing down to the tip to indicate where the bony area is. Draw two sections in the inner wing and two larger ones on the wingtip area.

6 Draw the pupil of the eye and holes for the nostrils on top of the beak. Finish adding body definition, like a line showing the inner ear and lines showing scruffy fur or feathers along the back, tail, and hind feet. Add a tongue inside the beak. Draw scales on the front legs—large scales on the main leg and scales on top of each toe segment. Add the backmost wing by drawing a line just above the top outline of the wing. Add the alula, or "thumb" feathers near the bend of the wing. Finally, add each feather using a hook shape along each row.

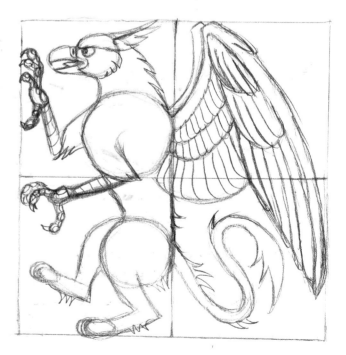

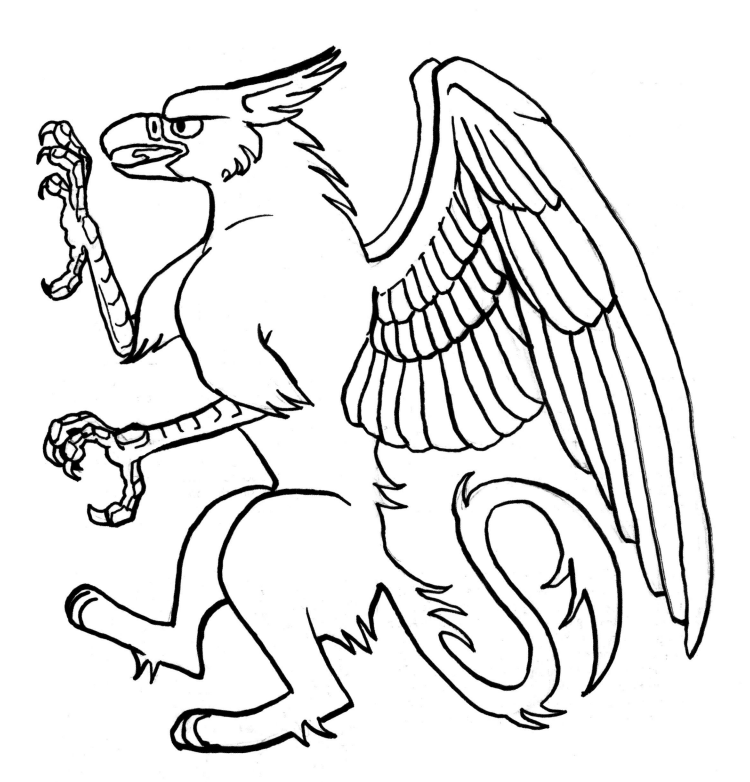

7 Finish the drawing by inking it in and erasing guidelines after the ink dries. (I added a hint of the backmost ear while inking this in and used somewhat broken lines along the inside base of the wings. I also did not draw all of the line behind the eyeball, making that line more of a furrowed brow that doesn't quite meet the ear.)

Hippogriff

The hippogriff is a flying steed with the front half of an eagle and the back half of a horse. It is said to be the result of breeding between a horse and a gryphon (which usually eats horses). No wonder they represent an impossible thing made possible. While the gryphon is a meat-eater and known for its ferocity, the hippogriff is usually seen as a more docile and even-tempered creature, able to be tamed and ridden, often by wizards or knights. It is an omnivore, eating both plants and animals, and an extremely fast flier. It will defend its nest and young fiercely.

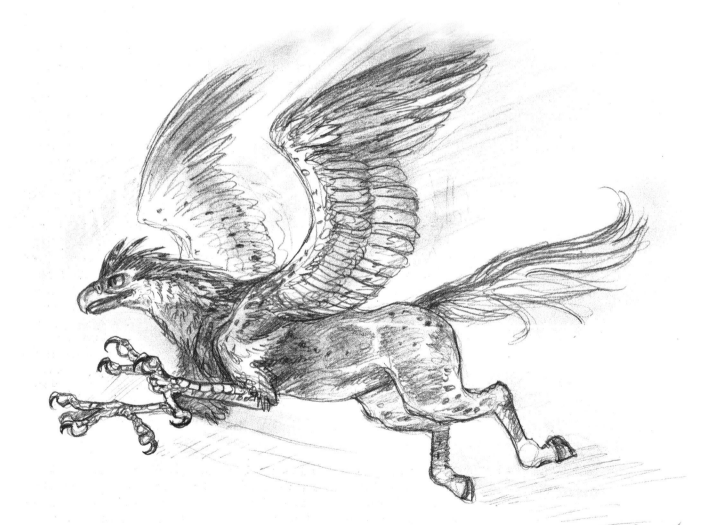

✦ A hippogriff in full flight.

STEP-BY-STEP HIPPOGRIFF

 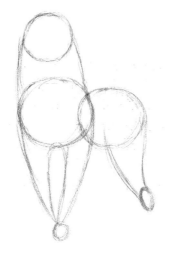 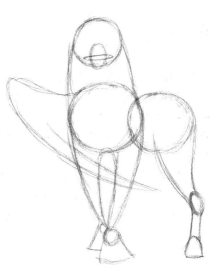

1 First, draw a circle for the head and then a larger circle for the chest under it, leaving room for a long neck. Add another circle for the hips that overlaps the chest circle and is only slightly smaller (because it is further away).

2 Draw slightly curved lines to connect the head circle to the chest, then continue downwards to block in the front legs with a curved line from each side that meets at a tip. The distance from the top of the head to the chest circle should be roughly equal to the distance from the chest to the tip of the front legs. Lightly draw a teardrop shape inside for the inner legs; you'll fine-tune it later. Add a circle for the foot under the front leg (on your right), which will be slightly closer to the viewer. Draw a hind leg (the closer one) from the hip circle, curving outwards from the hip to an oval for the hock (or ankle).

3 Draw an oval (longer vertically) in the lower half of the head circle, then bisect it with a thin, horizontal oval as shown. This is the beak base. Block in the front feet by adding a somewhat bell-shaped triangular form to the legs, first to the closer leg (on your right). Add a small circle to the leg on your left, which is further away, and a partial, smaller version of the bell shape you added to the closer leg. These bell shapes will be the toes. Finish the hind leg with a tube that ends at a bell shape for the hind hoof. Begin the right wing, sweeping out from the chest circle to a rounded tip that bends down to sweep a wingtip towards the hind leg. Don't worry about overlapping lines yet. I find it helpful to begin a wing by placing the top outline and wingtip over the blocked body. The rest follows more easily after those are figured out.

4 Go back to the beak base and erase the overlapping lines inside, leaving it blank. Draw a curved line originating near the top of the head and circling down to hit the top of the beak base. This is the brow. Next add three toes (roughly rectangle-shaped) on each front foot, leaving space between some if you like. Draw the hoof on the closer hind foot and then begin drawing the backmost hind leg, echoing the shape of the closer hind leg to some degree. Add another bell shape to the bottom for that hoof. Add more of the hippogriff's wingtip and then a row of smaller feathers closer to the bony base of the wing to show how it folds back. Now block in the other (open) wing, starting with a line sweeping from the chest circle that curves up to meet the top of the wingtip. Make the wingtip a slightly curved teardrop or chili pepper shape, pointing down towards the ground.

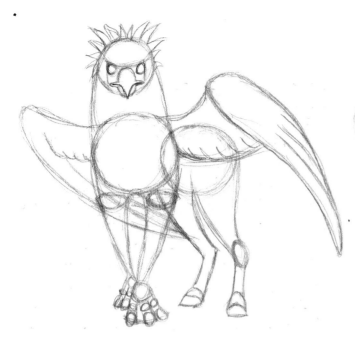

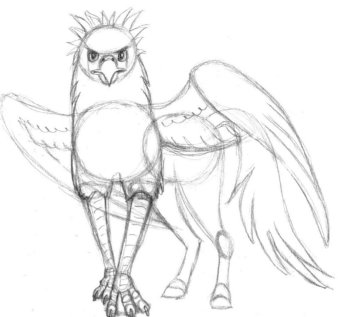

5 With the beak space now blank, draw an elongated V-shaped line from one mouth corner to the other, giving it a hooked tip in the middle. Draw some feathers or tufts on top of the head and add the eyes. The outside of the eyes should line up with the mouth corners. Finish the open wing, drawing a row of feathers and more along the wingtip. Finish the hind legs, adding hooves. Draw two small circles in each toe for joints on the front feet and then add some ovals where the front legs meet the body. These will be joints where feathers meet scales.

6 Add pupils and highlights to the eyes, letting the curve of the brow overlap on top to create a stern eagle-like look. Draw the nostrils or nares (including the rim around the nostrils). Define the feathers on the neck and add some wing details like rows of feathers. Draw the tail and the belly. Lastly, refine the front legs. Define the toes, letting the joints be slightly knobby and wider than the rest of the toes. Draw the claws. Make the joint where leg meets body more distinct, drawing the feathers on the body wider than the scaled part of the legs, which you can make thinner and more straight as you go down to the foot. Add scales as you wish.

7 Finish by inking in final lines and erasing guidelines as needed after the ink dries. (On the toes I often add a circle or square shape over the foot and over each knuckle to add some scaly detail. Drawing part of a square can also suggest scales. Consider adding a small interior curved line to indicate the tendons in the ankle or hock of the hind leg.)

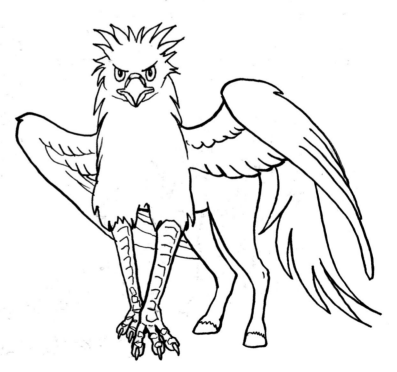

Phoenix

The phoenix is famous for its immortality, usually achieved by "dying" as it bursts into flames only to emerge from the ashes, reborn. It is often shown as pheasant- or falcon-like. Associated with sun and fire, it is said to live about 500 years before needing to regenerate, lining its nest with spices and incense such as myrrh, frankincense, and cinnamon, as it dies and is reborn. It is described as eagle-sized or larger and often said to be shades of red and yellow, though some accounts describe it as purple and red or even peacock-colored. The phoenix seems to be confused or intermixed sometimes with other mythological birds. For instance, the Chinese fenghuang is sometimes called the Chinese phoenix, though the two birds seem to have separate origins and the fenghuang is not usually considered immortal.

In Iran, India, and elsewhere there is sometimes a phoenix-like bird called the huma. Like the phoenix, it may burst into flames every few hundred years, then rise again from the ashes. The huma is said to never need to rest, constantly flying high above the ground. Anyone fortunate enough to see one is blessed by good fortune. It is also said to have both male and female natures in the same body. It feeds on bones, not living creatures. If it flies over a man, casting a shadow on him, he will become a king. Humas lay eggs in the air and the chick hatches before the egg hits the ground, escaping and flying up to safety.

✦ Below is the simurgh, a phoenix-like creature from Iranian legend. It is large enough to carry off a whale and, like several other mythological birds, has enmity towards snakes. Sometimes depicted as mostly bird-like, the simurgh may also have the head of a dog or, rarely, a human. Its tail feathers are long and may be like a peacock's or may be copper-colored. Rarely, it may have four wings. A good omen, the simurgh is a messenger who represents purity and has a motherly, protective nature (it is most often depicted as female). As with the phoenix, tales say that it may live 1,700 years or so before it regenerates in flames. Sometimes, it is said to be even older than that, gaining great wisdom.

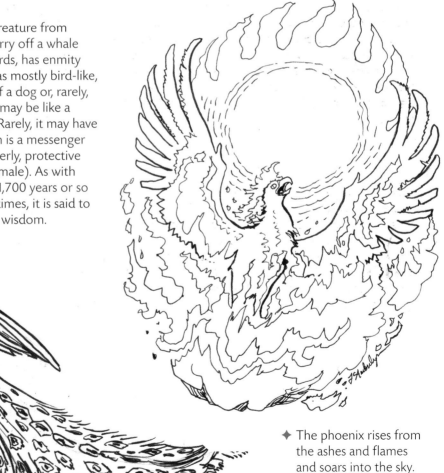

✦ The phoenix rises from the ashes and flames and soars into the sky.

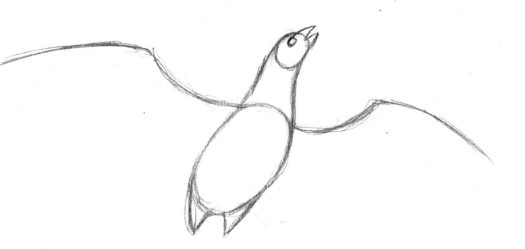

1 First draw the head (as an almost circular oval), neck, and body. The head, neck, and body together should look a bit like a gourd, with a long neck ending in a rounded tip. (I have it angled flying up from the bottom left and pointing to the top right.) Leave room for the tail below and widespread wings on the sides.

2 Add an open beak and an eye (the top of which can line up with the top of the beak as shown). Draw the top part of the wings, leaving the one on the left slightly longer than the one on the right, since the one on the left is a little bit closer and thus would appear slightly larger. Draw two triangular points on the bottom of the body to begin the legs.

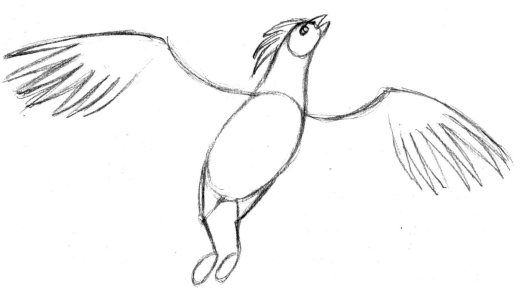

3 Add a crest to the bird's head and, for the nostril, a dot where the top part of the beak joins the head. Draw the eye's pupil and add the legs (which should angle out subtly towards the belly from the triangular bases of the legs you drew in Step 2). Block in ovals at the ends of the legs for the feet. Now add the primary feathers (wingtips) to the wings. (I drew seven primary feathers on each wing.)

4 Draw the underside of the wings. At this point, just block them in with curved lines that connect the wingtips to the body. Draw the tail, making it a sweeping teardrop or chili pepper shape extending from the body. Draw small teardrop-like shapes inside the foot ovals to begin depicting the toes, leaving more space on the right than the left (the space you leave will be the toes and there are more to the right than the left). Give the legs thickness by drawing lines along and next to the ones you drew in Step 3.

5 Add details to the tail, making jagged indents all along the rim to indicate long feather tips. You can do this to the neck as well. Draw the toes. Draw more details in the wings, sketching in a line underneath the top outline to indicate the arm bone structure underneath and the very short feathers found along that area. Draw the secondary set of feathers between the top of the wing and the wingtips.

6 Finish drawing details on the phoenix, adding a ruff of feathers along the chest if you like, as well as lines running perpendicular to the bird's legs to indicate scales. Draw claws on the toes. Add details to the tail, including more indications of the length of the tail feathers as well as spots or other decorations. Complete the wings, adding two levels of feathers closer to the body.

6A Note how the feathers curve and can appear larger or smaller depending on their distance from the viewer. In this phoenix, there is a slight curve towards the left side of the drawing because this is where the wing is just a bit closer to the viewer. The feathers overlap and the nearest side would be where you begin, drawing a feather, then overlapping from there. Many of the feathers in a section or row are about the same size, but those closer to the viewer would appear to be a bit larger. I've used arrows to show the general direction and curve of feathers on the wing from various angles.

6B Here one wing is much closer to the viewer than the other. The dotted lines show perspective and how the further wing recedes into the distance. The further wing's feathers also look smaller as the wing angles away.

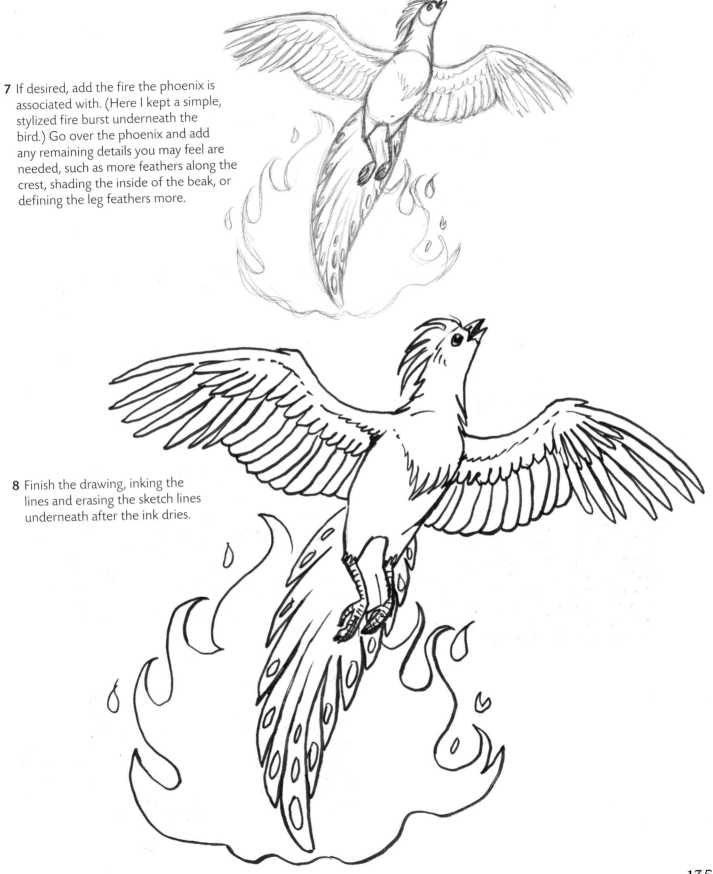

7 If desired, add the fire the phoenix is associated with. (Here I kept a simple, stylized fire burst underneath the bird.) Go over the phoenix and add any remaining details you may feel are needed, such as more feathers along the crest, shading the inside of the beak, or defining the leg feathers more.

8 Finish the drawing, inking the lines and erasing the sketch lines underneath after the ink dries.

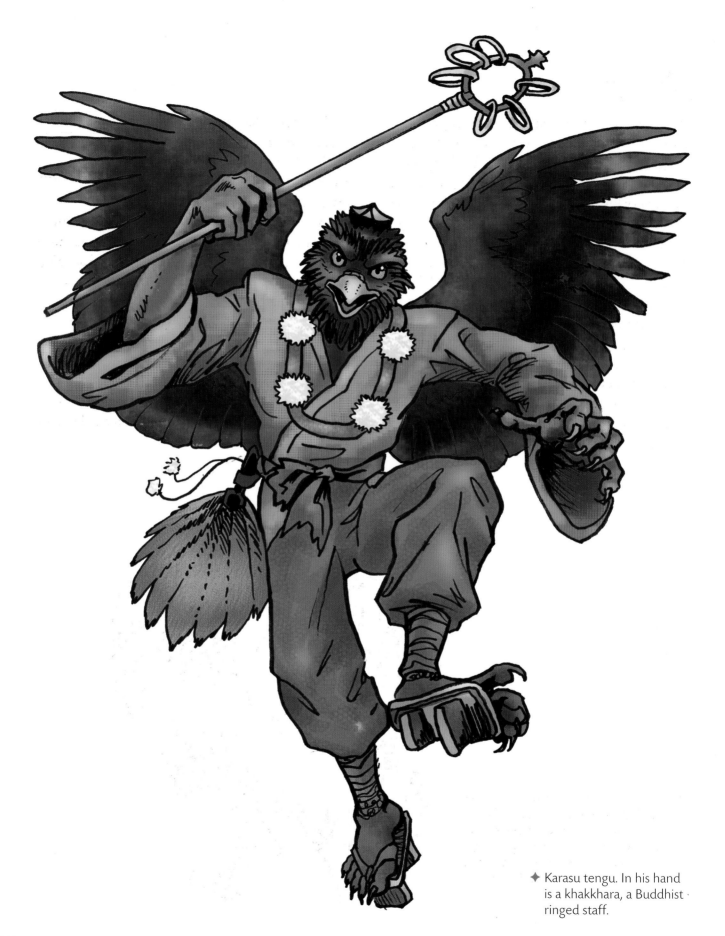

✦ Karasu tengu. In his hand
is a khakkhara, a Buddhist
ringed staff.

Tengu

The tengu is a yokai (monster or spirit) of Japan's mountains and forests. Its depictions vary, ranging from a monstrous kite (a bird of prey) or a crow-like bird to a more humanized figure that has a very long nose and red skin. They are often associated with yamabushi (one who prostrates himself on the mountain). Yamabushi are mountain priests who live isolated, frugal lives, shunning most material comforts as they practice the old Japanese religion Shugendō. Tengu are often depicted wearing a priest's small, round, black cap (tokin), sash with pom-poms, and short robes. They may also carry a khakkhara, also known as a shakujo, a staff used by Buddhist monks, or a fan made of feathers that can stir up the wind. Tengu have the power of flight, the ability to produce great gusts of wind, and sometimes have shape-shifting abilities.

Tengu can be good or evil. Evil tengu cause havoc, abducting people, often children, and leaving them stranded high in trees or making them go mad. They may try to trick Buddhist priests and burn temples. Some are said to be the ghosts of arrogant humans whose pride led to their downfall. However, good tengu have become more common in recent centuries. Still depicted as vain, they're now willing to guide or help humans in need. Instead of causing mischief at temples, they may guard them, and they protect lost children as well. The great tengu Soujoubou, or the King of Tengu, is said to have taught swordsmanship to Minamoto no Yoshitsune, a famous warrior, on Mount Kurama. In fact, tengu are considered to have excellent combat skills and may teach humans some of their techniques.

◆ Yamabushi tengu. There are generally two kinds of tengu. The lower class is the karasu tengu, which appears more crow-like. The higher-ranking tengu, which appears more human and has a long nose, is the yamabushi tengu.

Thunderbird

The thunderbird is a supernatural bird found in the tales and culture of some North American indigenous people. It is especially prominent among Pacific Northwest cultures but is known to people in various other places, particularly in the Southwest. The thunderbird is so named because it creates thunder by flapping its massive wings. Sometimes it controls lightning or rain, and lightning may come from its eyes.

Thunderbirds are large enough to capture and eat small whales, though they usually live high in the mountains. They are sometimes depicted as the enemy of supernatural snake-like beings and underwater or underworld spirits, and thus they protect humankind. Thunderbirds are highly moral, relishing great deeds and sometimes punishing evildoers. In some cases, thunderbirds are shape shifters, able to take on human form as desired.

✦ Some legends tell of an epic battle between the thunderbird and an evil, monstrous orca. The thunderbird picked the whale up and dropped him on land, causing thunderous sounds heard throughout the area. A major fight ensued, which the thunderbird finally won.

Vermillion Bird

The Vermillion Bird is part of the Four Symbols in China: the Azure Dragon (East), the Vermillion Bird (South), the White Tiger (West), and the Black Turtle (North). They also represent constellations. These sacred creatures are known in China, Korea, Vietnam, and in Japan, where the Vermillion Bird is known as Suzaku. It is a graceful, reddish (sometimes five-colored), pheasant-like bird covered in flames and represents the south, the element of fire, and the season of summer. It is linked to the Hydra, Corvus, Crater, Gemini, and Cancer constellations. The Black Turtle (or Dark Warrior) of the north (often depicted as a turtle-snake combination) represents winter and water, the White Tiger of the west represents metal

and autumn, and the Azure Dragon of the east represents spring and wood. The Black Turtle is also linked to the Pegasus, Capricornus, and Sagittarius constellations, the White Tiger with the Taurus, Orion, and Andromeda constellations, and the Azure Dragon with the Scorpio, Libra, and Virgo constellations. Sometimes there is a fifth part: a Yellow Dragon, who resides in the center and represents the element of earth and the changing of the seasons.

✦ The Vermillion Bird is prominently featured in this depiction of the Four Symbols (clockwise from top): the Black Turtle, the Azure Dragon, the Vermillion Bird, and the White Tiger. The Yellow Drago is in the center.

Wyvern

The wyvern is sometimes considered a dragon and sometimes not, but it is easily distinguished from one by the fact that dragons have four legs and wyverns have two. The wyvern has an otherwise dragon-like head and wings, a reptilian body, and a long, scaly tail tipped with a barb or arrow point. A sea wyvern will have a fish-like tail instead. Wyverns generally aren't fire-breathing like many dragons are, though there seem to be occasional records of fire, ice, or poison-breathing wyverns. In general, wyverns are like smaller, less intelligent dragons. They can be aggressive and are inclined to hoard treasure much like a dragon does, but the quality of their treasure may leave something to be desired. Wyverns have long been used as heraldic mascots.

✦ The aggressive character of the wyvern is apparent in this drawing. It's easy to see why these creatures are used as heraldic mascots.

✦ A preliminary sketch of the drawing above. I blocked in the head, neck, and body, then added the rest.

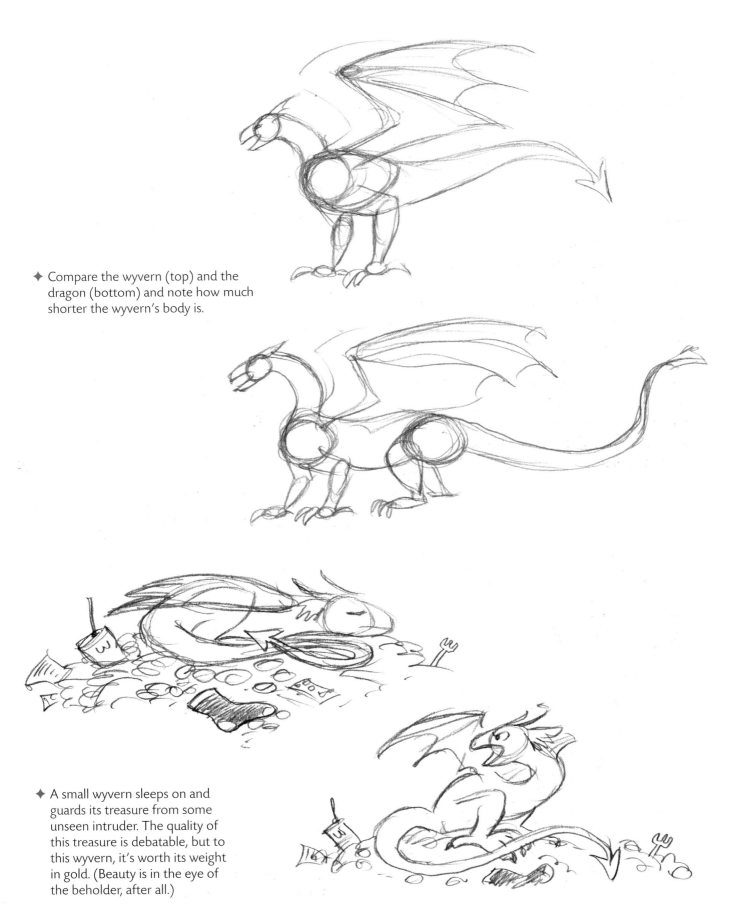

✦ Compare the wyvern (top) and the dragon (bottom) and note how much shorter the wyvern's body is.

✦ A small wyvern sleeps on and guards its treasure from some unseen intruder. The quality of this treasure is debatable, but to this wyvern, it's worth its weight in gold. (Beauty is in the eye of the beholder, after all.)

5

Creatures of the Water and Spirit

This chapter takes a look at some of the rest of
the creatures of myth and legend, from those that lurk
in the water to those that lurk in the realms of the
spirit and underworld.

Afanc

This creature of Welsh legend is sometimes seen as beaver, crocodile, or dwarf-like being. It is said to inhabit certain lakes in Wales and is sometimes dangerous to humans, attacking anyone foolish or unlucky enough to fall into the water. If angered, the afanc may thrash about and cause massive flooding, drowning people and livestock. While in water it is powerful, but if it can be dragged onshore it loses power and is easier to defeat or kill. Tales speak of a beautiful maiden luring an afanc to rest its head on her lap and fall asleep. Villagers, waiting in ambush, then chained the creature and dragged it to a faraway lake with steep slopes the afanc couldn't escape. There are some legends saying that King Arthur himself killed one of these creatures, using his horse Llamrei to drag the foul beast from a lake with a chain around its neck. The horse left an imprint in the rock that can be seen to this day.

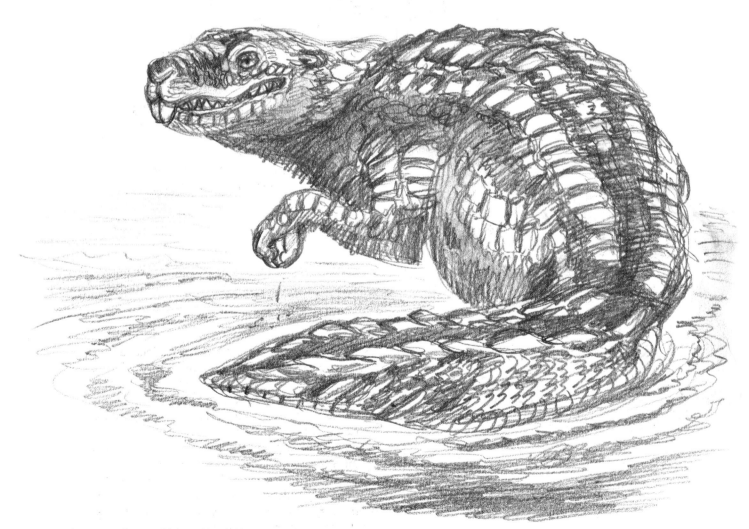

✦ Many afancs of legend look like crocodiles.

Akhlut

The akhlut is a creature that appears to be a cross of wolf and killer whale, or orca. It usually looks like a large orca but when it becomes hungry it shape shifts into a more wolf-like form to hunt on land. These big carnivores hunt down both humans and animals they encounter, then, when full, return to the sea in orca form. Wolf tracks entering the ocean can be a sign of an akhlut, or so it is said.

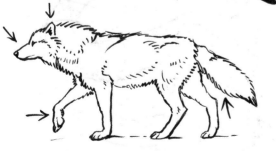

✦ The akhlut is a true blend of an orca while in the sea, and a wolf while on the land.

✦ I used arrows to point out some of the distinctive features of the orca on top and the wolf on the bottom. The orca is characterized by the prominent, rounded forehead, fin, tail, and distinctive black-and-white markings. For the wolf it's the long muzzle, pointed ears, big dog-like feet, and bushy tail that are distinctive. To draw the akhlut I combined all those features, giving it a wolf's body and ears and a large, rounded, whale-like forehead, fin, and orca markings. The small sketch shows a basic head shape, which I gave a rounded, sloping forehead. Use distinctive features of specific animal species when combining two or more together into chimerical creatures.

Baku

Baku are associated with health and good luck and have the power to eat bad dreams. In Japan, these shy, supernatural creatures share a name with the real-life animal known as a tapir in English, and they share some physical characteristics, like their long, almost elephant-like trunk. The mythological baku is said to have an elephant's trunk and tusks, the eyes of a rhinoceros, an ox's tail, and the feet of a tiger. It is often yellow and black. According to legend, a person who wakes up from a bad dream can call upon the help of a baku to eat the nightmare so they can sleep peacefully. However, over-relying on a baku may cause it to eat one's hopes and dreams as well, so respect should always be given.

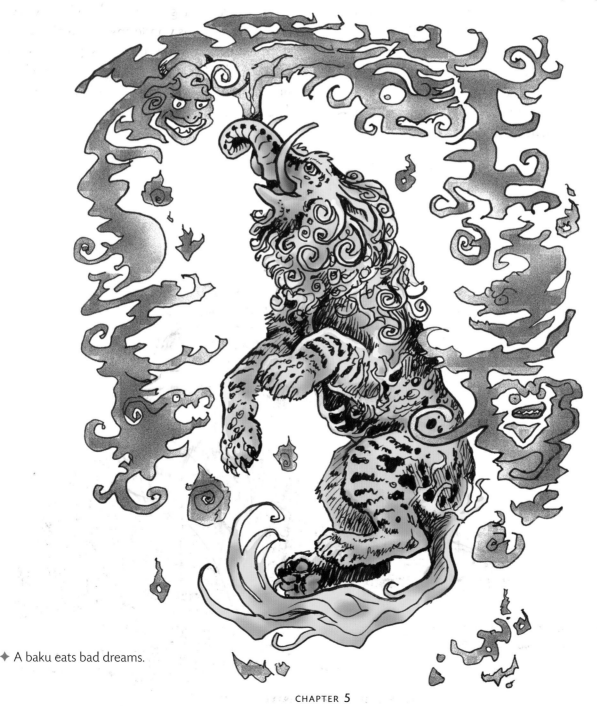

✦ A baku eats bad dreams.

Bunyip

The bunyip comes from Australian Aboriginal mythology. It is a creature said to lurk along Australian swamps, rivers, creeks, billabongs, and other bodies of water. It's hard to say what it looks like exactly, for there have been all sorts of descriptions of the creature. Some report it as something with a crocodile head, some as having a dog's head, other times it appears more wombat-like, sometimes bird-like, sometimes more like a seal. The bunyip is often reported to have dark fur and it almost always has sharp teeth and claws. This leaves a lot open to artistic inspiration, so artists can choose a look that speaks to them. I ended up drawing from seals, crocodiles, and marsupials for my interpretation.

Bunyips are known to produce loud, booming calls that can be heard from long distances. (The real-life Australasian bittern, a marsh-dwelling bird, also produces loud calls and is sometimes called the "bunyip bird" because of this.) Bunyips lurk in water, waiting to attack people or animals that get too close to their home. There is some speculation that the legend of the bunyip may be a result of seeing seals wandering inland along riverways or even ancient memories, passed down over thousands of years by Aboriginal Australians, of the extinct diprotodon, which used to be the world's largest marsupial.

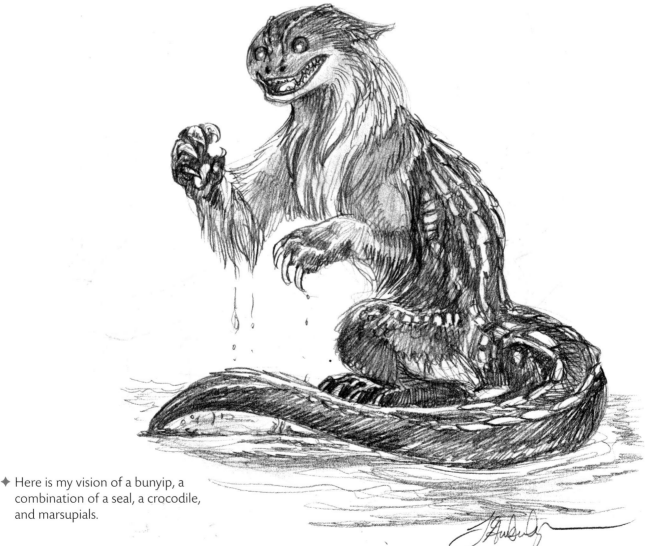

✦ Here is my vision of a bunyip, a combination of a seal, a crocodile, and marsupials.

Cerberus

Cerberus is the (usually) three-headed dog of Greek mythology that guarded the gates of the Underworld. However, there are varied accounts, and Cerberus can be depicted as having from one to fifty heads. He usually has a snake's tail in the old tales and sometimes he has snakeheads growing on his main heads or on his back. Some accounts tell of this monstrous hound's fire breath or his ability to spit poisonous foam. He is loyal to his master and fierce to any who try to escape the gates he guards. He can be a bit of a glutton as well. He is most famous for the tale of Heracles (or Hercules) in which Heracles, as one of his Twelve Labors, is sent to capture Cerberus and bring him up to the world of the living. He succeeds in the task, in some stories wrestling the immense dog into submission. Modern accounts may show Cerberus or a creature that looks like him guarding underground gateways. These three-headed hellhounds may or may not have snake-like features, but they usually have the three dog heads and a ferocious temperament.

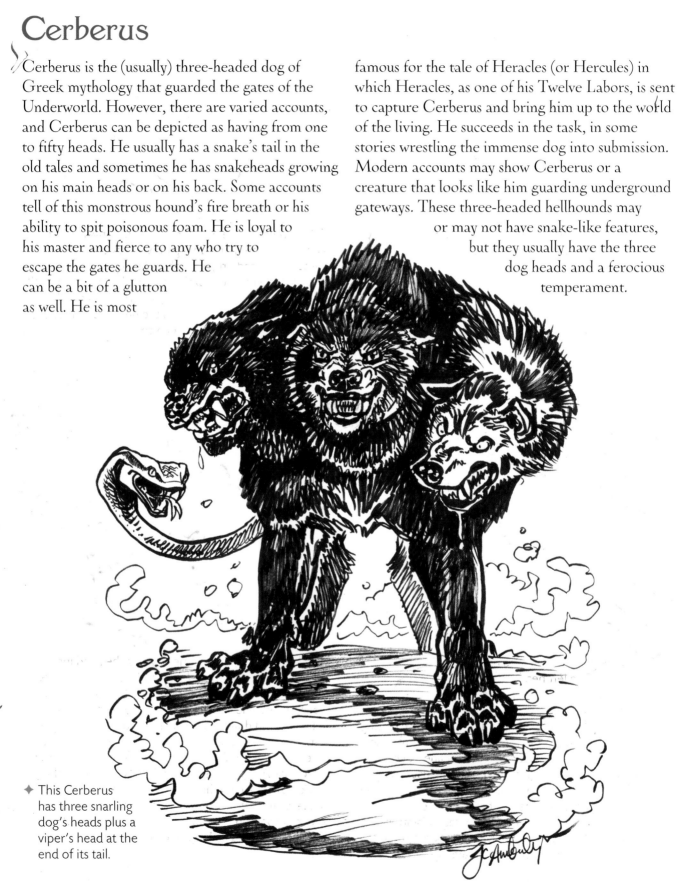

◆ This Cerberus has three snarling dog's heads plus a viper's head at the end of its tail.

STEP-BY-STEP CERBERUS

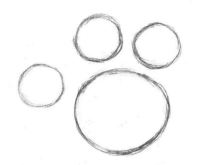

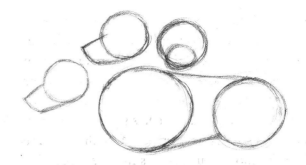

1 This will be a three-quarter view of Cerberus. Begin by drawing a larger circle for the deep chest of the "dog" and three smaller circles above it for the three heads.

2 Add muzzles to the heads, drawing a relatively straight line on top and then curving down back towards the throat. The head on your right is facing the viewer, so draw a circle for the muzzle on roughly the bottom half of it. Add a circle for the hindquarters that is smaller than the chest but bigger than the heads. Connect it to the body, giving the dog a deep chest. .

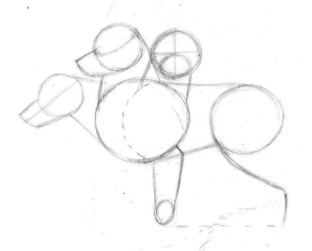

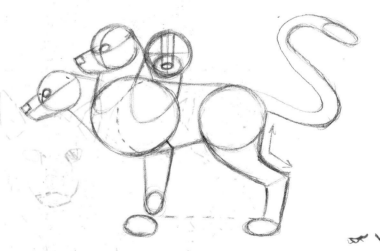

3 Draw some guidelines on the heads to help you place the features. The left head: draw a straight line to divide the head horizontally; the center head: a three-quarter view, so draw a curved line in the center of the circle; the right head: looking straight at you, so draw crossing horizontal and vertical lines centered over the muzzle. Next draw the shoulder and extend the line down to form the front leg, drawing down to the wrist (you can add a joint circle there) and then looping back up to the elbow as shown. Draw the front of the closer hind leg. The dotted line shows how the front leg wrist joint and the bottom of the hind leg above the paw are roughly level. Draw necks to connect the heads to the chest.

4 On the left head, draw a line dividing the head into equal top and bottom sections and add an eye where the head meets muzzle, above that line. On the center head, draw a line from the side of the muzzle to the forehead and draw the eye just outside this line in the center. For the right head, draw a parallel line on each side of the center line from the top of the head to the nose oval. Add the noses to each head and finish the necks. Complete the hind leg with a nearly 90-degree angle at the back, as emphasized by the arrows. Draw the foot ovals on the front and back legs. Draw the snake-like tail and include an oval for the head at the tip.

5 Add eyes to the head on the right and then pupils to all the eyes. Draw the mouths. Each head can have a different expression if you wish. Add the ears, which can be erect or floppy (I chose erect, so they are triangular and pointing upwards). Connect the wrist to the closer front leg and then draw the backmost front leg and foot, leaving the connecting of the wrist for last. Add the backmost hind leg and divide the snakehead in half, then add an oval for the eye.

6 Finish the details, including connecting the paw to wrist and adding toes (including the dewclaw). Draw highlights for the noses and eyes and add rims to the front of the ears, as well as squiggly lines inside to indicate hair. Draw the teeth if a head is snarling and define the shaggy fur along the necks and body. Add the hollow spot in the ankle of the hind foot and give the snakehead on the tail an eye and draw the mouth and forked tongue. Note that I gave this snake a slightly upturned nose.

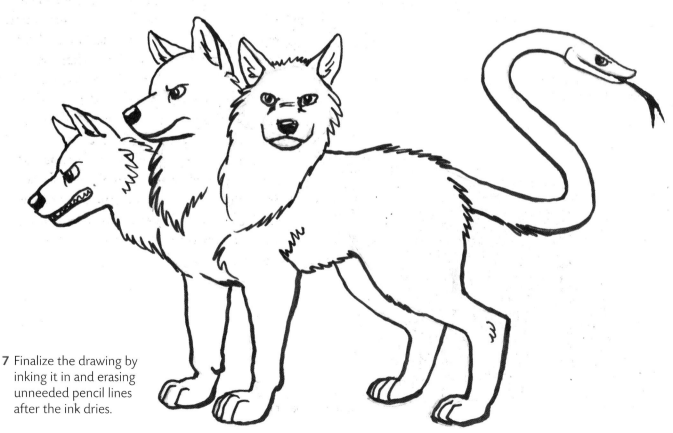

7 Finalize the drawing by inking it in and erasing unneeded pencil lines after the ink dries.

Kappa

The kappa is a Japanese water imp yokai (spirit or monster). It has a turtle-like shell on its back and is usually depicted as green and slightly humanoid in shape, with webbed hands and feet. It has a depression on its head that carries water, the source of its power, and if the kappa accidentally dips its head and spills the water it will weaken or even die. It can be mischievous and amusing or sinister and deadly. Resourceful humans have tricked the kappa by bowing to it; the creatures are obsessed with politeness and if someone bows to them, they must return the gesture. A defeated kappa may give wisdom or multiple favors in return for sparing its life. Some kappas are helpful to humans while others are nasty creatures that may drown and eat unwary people near the water's edge. They are especially hostile towards cows and horses.

Kappas are known to have a taste for cucumbers as well as human intestines, a great deal of medical knowledge (kappas are said to have taught people how to set broken bones), and they enjoy sumo wrestling! Sometimes they are pranksters, passing gas loudly to surprise people.

Kappas are generally vaguely humanoid as well as reptilian or amphibious in shape. Some think that the kappa might have been inspired by the Japanese giant salamander, which can grow to 1.5 meters, or about 5 feet long.

✦ This kappa is eating a cucumber, one of its favorite foods.

✦ Some kappa heads.

1 In this quick sketch, I blocked in the basics of the kappa's body: a circle for the head, oval for the body, and lines, tubes, or long triangular shapes for the limbs. I drew ovals for the hands and indicated the fingers on the hand resting on the kappa's hip. I drew horizontal and vertical lines to divide the head into quarters, curving the vertical line slightly to the viewer's right, which is where the kappa's face points slightly.

2 I added details, drawing circles for eyes along the horizontal dividing line, an oval for the beak-like mouth on the lower part of the vertical line, and blocking in more of the hands and feet, including the claws on the feet. I drew a curved, somewhat horizontal line for the chest and a vertical one going down the body center. I added "hair" on top of the head and a tail sticking out behind and below the body.

3 I added more details: the depression on the kappa's head, highlights in the eyes, an almost V-shaped line for the mouth. I drew the bangs between the depression on its head and the eyes. I added a circle for the belly plate on the body and claws and webbed fingers on the hands. I defined the toes on the feet and added scaly details on the limbs.

4 I finished the drawing, inking it in and erasing pencil lines after the ink dried.

Kelpie

If you are traveling alone in Scotland on some dark moor or the edge of a loch (lake) and you see a horse near the edge of the water, saddled and bridled and seeming to want you to ride it, beware! You may have encountered a kelpie! These malevolent water horses can sometimes shape-shift into the form of a human to lure people closer. In horse form, they trick humans into riding them; these victims will soon be horrified to discover they are stuck onto the horse's hide and cannot get off as the kelpie drags them into the water and drowns them for a meal. But, there is one thing you can do if you ever find yourself in this situation. Take control of the kelpie's bridle and it will bend to your will. Said to have the strength of ten horses, a kelpie could be a valuable asset indeed.

There are some similar tales of water horses elsewhere in the world, including the Nykur of Iceland. Both it and the kelpie have reversed hooves that point back instead of front. To defeat a nykur you have to say its name. The nuckelavee is another horse-like evil creature that lurks along seawater. It appears as a horse with a man's torso attached to its back but it doesn't have skin. This demon wilts crops and brings drought with its breath. It will attack people but can be escaped by crossing any kind of fresh water, such as a stream, for the nuckelavee cannot tolerate fresh water of any kind.

✦ This kelpie has a bit of a skeletal and possessed look to its face.

Hippocampus and Aigikampoi

The hippocampus of Greek, Etruscan, and Phoenician mythology is part horse (in front) and part fish (in back). Poseidon, the god of the sea, was sometimes depicted being driven across the ocean on a chariot pulled by hippocampi. Occasionally winged hippocampi are seen. Hippocampus-like sea horses of some kind are also seen in other parts of the world at times. There is a real-life animal known as the seahorse, which is actually a type of fish and much smaller than any hippocampus. The scientific name for its genus, or the group of species known as seahorses, is *Hippocampus*. For instance, the Pacific Seahorse is known by the scientific name *Hippocampus ingens*.

In addition to sea horses, there are other fish-tailed animals in Greek and other ancient mythology and art. There are artistic depictions of fish-tailed lions, leopards, and bulls. There is also the aigikampoi, or fish-tailed goat. It is probably best known today as the Capricorn of astrological signs. An old Greek tale tells of the immortal sea goat Pricus, who kept watch over his many children, also intelligent, speaking, fish-tailed goats who loved to play on the shoreline. However, the longer they played on land the more like goats they became until they no longer had fish tails, nor could they speak or remember who they were. Pricus tried over and over to wind time back so that he could stop his children from forgetting, but no matter how often he tried, it was futile and they always changed. Eventually he cried to the god of time, Chronos, to let him die so he wouldn't be alone anymore. Instead, Chronos sent him to the night sky as the constellation Capricorn so that he could forever watch over his children.

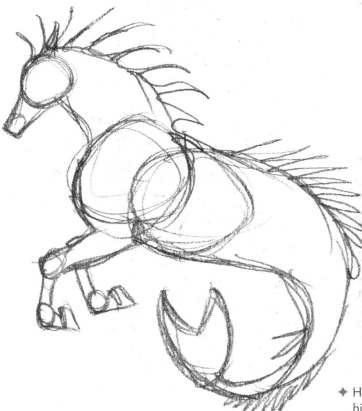

✦ Here are sketches of the basic body shape of a hippocampus (left) and an aigikampoi.

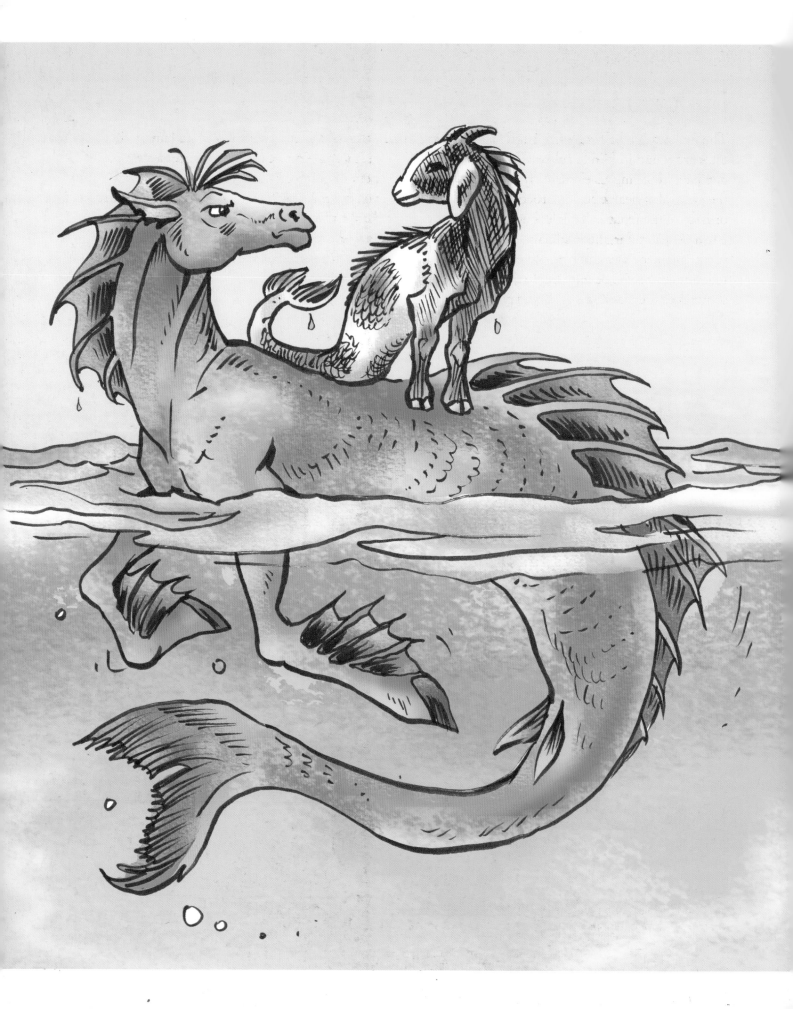

Makara

The makara is a half-terrestrial and half-aquatic creature found in Hindu culture. It is usually depicted as having an elephant-like trunk, with the general appearance of a crocodile, elephant, or deer in the front half of the body, and (usually) a fish or seal tail in the hind half. There may be variations, such as more plant-like or peacock-like tail. Sometimes it has only the two front legs and sometimes four legs on a crocodilian body. It can have lion-like feet, boar's ears, and human-like eyes. Makara may carry holy figures across the waters and are commonly depicted guarding temples, gateways, throne rooms, and other thresholds. Pearls sometimes come out of their mouths. They are associated with water and fertility. In Hindu astrology, the makara is the equivalent of the Capricorn.

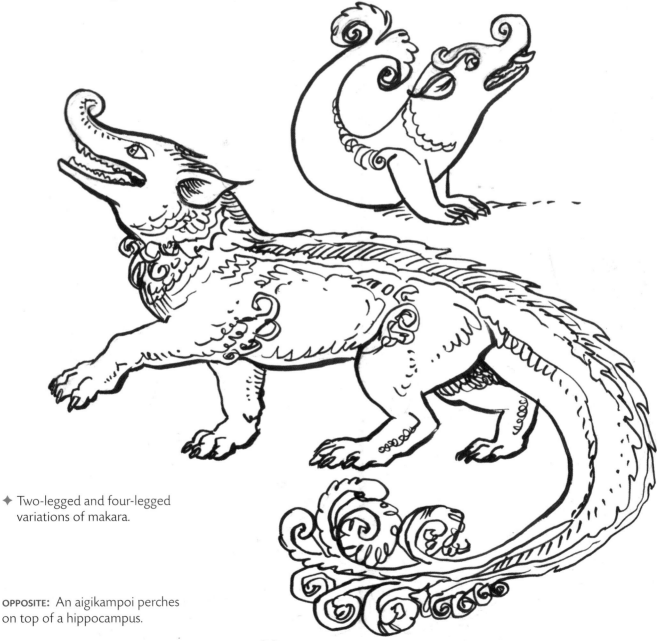

✦ Two-legged and four-legged variations of makara.

OPPOSITE: An aigikampoi perches on top of a hippocampus.

Index

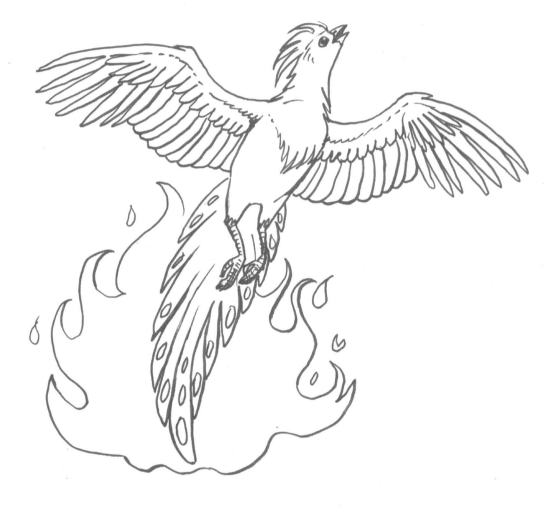